Neon Fish
in Dark Water

Neon Fish
in Dark Water

Illustrated by the author

Aniket Jaaware

MapinLit
AN IMPRINT OF
MAPIN PUBLISHING

First published in India in 2007 by
MapinLit
An Imprint of
Mapin Publishing

Mapin Publishing Pvt. Ltd.
10B Vidyanagar Society Part I, Usmanpura, Ahmedabad 380014
T: 91 79 2754 5390/91 • F: 2754 5392
E: mapin@mapinpub.com • www.mapinpub.com

ISBN13: 978-81-88204-71-4 (Mapin)
ISBN13: 978-1-890206-99-4 (Grantha)
LC: 2006938650

Designed by Janki Sutaria / Mapin Design Studio
Printed in India

Contents

For *Urmila*
who made me write my first short story

Love: Store in a Cool Dark Place

My lover is dying of cancer, and he knows it. I am dying of cancer, and he knows it too. This knowledge enables us—but no, that's not how I should tell you. I should tell you things as they happened. Old-fashioned narrative painting is something that I've always liked so I will now make your eye traverse the planes of this painting, making it linger on certain areas, and move quickly with the force of lines over certain others. But perhaps you should know that after a year of this knowledge, we decided not to take any serious treatment, because most of it is useless anyway. I am going to paint this picture with cool colours, almost dry, because what I want to convey is the sense of calm that we both have. A very dry acrylic perhaps, yes, but with a pastel finish and shapes that might remind you of the very peace-inducing Cézanne. Oh, but how I wish I could paint like Poussin.

As you probably have begun to imagine, in your own way, that I am a painter, or perhaps an art critic, I should tell you that I am a painter. You know, my doctor is very wealthy by now, I have known him since he was in school with me, and like many well educated rich persons, he has begun to collect art-objects, and read up on painting and painters, and I think he secretly worries about what I will do with this knowledge that I am dying, and all this because he's read up some old biography of Van Gogh, I mean that is all that he knows of Old One-Ear Sunflower. Spare me that kind of reading. And no, I am not wealthy but I am not very badly off either. It's interesting how people react when they come to know that I am a painter. The wealthy ones, like, squeeze their faces up into an expression which can only mean Ooh, you poor thing, what do you do for a living then?, and of course if you are in their house, they begin to make sure that you are not going to dirty their place in some way. Also, for some strange reason, they begin to look at your clothes. The educated ones, of course, immediately conclude that one is wealthy, because all *they* know

about painting is the figures of the sale of the last newly discovered Picasso. Now my lover, who is a pharmacist, evokes no reaction at all, though he is, like, much more learned and suave and you know, polished-like. He often looks as if he was painted by Dürer or somebody like that who used, like, very fine brushes? Ya, that's how he looks, and he has long hair too. It is only kids below ten who take to you immediately, but you have to sketch something quickly to impress them first. After that, they will do anything for you. I love kids. I have even painted them once. Two kids hitting each other. Oh, you should see how kids stare and stare and stare at that picture. Unfortunately, I can't watch that anymore, because I had to sell off that painting. I have to eat too.

So, about, I think, three years ago, I got this call from a friend of mine, for a party that he was giving to celebrate the fifth year of his marriage. Now I don't like to go to such parties, where you have to be polite and all, where you cannot just drink yourself silly, but I was forced to go because I think he realized that I wasn't going, so he called up my doc, who is a friend of his too, and the doc suggested that I should go. Now that is very clever manipulation, as you will notice, because now if I don't go, the doc suggests, without stating it ever, that I am not going because I'm depressed by my cancer. So I have to go, right? And also, this friend does sometimes serve fantastic food, his wife is a great cook, a very sweet person, but then, it gets a little boring after a while, if you know what I mean. And there would be some form of alcohol anyway. In short, Dear Reader, I went for that party. I even took some flowers.

And, boy, what I discover there is that there is a bottle of Irish Cream which no one's touching because it's like polite not to go for the thing, right, so naturally I stand beside the bottle, and slowly begin to think that perhaps I should get drunk on it, when I notice this doctor friend welcoming a rather well-drawn chap, someone had done him up with a fine brush over all the broad muscular strokes, but someone who was better at line than at application of colour, because there were like some under-painted patches on the face. Nothing immediately noticeable, mind you, but after all I do notice such things. Professional hazard, I guess. And it was very strange, that combination there, because my doc is like put together by someone who is trying

hard *not* to be an analytical cubist, like, but cannot but think that he's as good as old Minotaurus (that's what I call Picasso) because he can use bold colours. I mean my doc, I am almost ashamed of knowing him, I mean he wears a red tie sometimes, and of course he is Chairman of the Rotary Club. And he works out hard in the gym, but he still manages to look as if stuck together, like a painting in different styles by diverse hands. But he is a good doc, and an old, old friend, so I am stuck with his shape and colours. Now this well-drawn guy, his forehead has this peculiar manner in which it suddenly turns towards his ears, which are smaller than they should have been. Ah, perhaps a musician, I think, because most musicians, ironically, are rather well-drawn people. And all of them have Dürer hands, all those I know anyway, and, surprisingly, rather small ears.

So here I am staring at this guy, and he surely notices something, because he suddenly looks up bang into my eyes. His are the purest of dark but coolest of eyes that I have ever seen. So as it usually happens, I look away (I don't want him to notice how small my eyes are, you know), but after that, we are both aware of each other like. I know instinctively that we will talk to each other before this party is over.

So there is this gaze-thing happening to us, we end up looking into each other's eyes from a distance in the next hour and a half or so, and eventually, as all this is happening while I am near the bar and right beside the bottle of Bailey's, I know this guy has to come and talk some time, but I am not sure what is going to happen because, as you can understand, I am not even thinking of a relationship then.

Later, as he came for a whiskey, I was already feeling warm and elated halfway through my fourth blissful of Bailey's. He smiled, and I did too, and then I heard this rather rich but delicate voice say hello. So I did too, and we are already looking into each other's eyes and smiling, and I almost knew, already, that I was falling in love. I have done it a few times, and know most of the symptoms. So I asked him straight about himself, we found a quiet corner, and talked about what he did and what I did, and it fascinated both of us. He was a pharmacist, and owned a store which did very well because he kept it open through the night as well. I asked him how could he do that, to which he replied, and his eyes shifted a little, and told me that he has

insomnia anyway, so he can do it by himself. I told him that I was a painter, but not very well-known, and not very rich. This is necessary to say. Well, he only stared at me, I mean he was impressed by that, can you believe it?

So I asked him where he lived, and he said, oh, above the store, you know. So I had to ask him where his store was, and he said, oh, it's in a cool dark place and started laughing uncontrollably. I did not understand, so he said, wiping his tears of laughter, oh, you don't understand—that's what all medicine boxes and bottles say, don't they now? Store in a cool dark place? Now, while he is talking and I am falling in love, I am also, like, noticing little inconsistencies of skin texture, his hands, his cheeks, the dryness of his lips, and slight redesigns of his throat. Now I know that these are marks of illness, but naturally, I did not have the courage to ask him. But it makes me more than interested, now I want to get to know him. I have been laughing at his joke heartily all this while, and he seems struck by it. Now I know everybody thinks I laugh too loudly, and some think hysterically, and of course some think hysterically because of "her illness", but he is not fazed by it at all, he is impressed. He doesn't find it odd at all, and I like that. So I go on laughing. So much, in fact, that he has to hold me by the shoulder, he thinks I just might fall down laughing or something. I mean, he is that embarrassed by someone laughing that much at his joke, he has cracked it at almost every opportunity, it seems.

Well, so as you can imagine, we just talked and talked and talked for half an hour, and then we both realized that we were being rather anti-social, huddled together like that. In fact, he senses it first, and with an apologetic smile, he gets up and begins to mix with others again. And I too then begin to talk to people, no longer standing tethered to the bottle, like, of Bailey's. I wonder if someone noticed at all, especially my doc, because he would then become all psychological and start giving me advice on my love-life too, though I have scolded him, and told him several times, to stick to cells and never to move up the scale to body or mind. But he had left a long time ago it seems, for some emergency call. After about fifteen minutes of small talk to all and sundry, I begin to go back to my Bailey's, and half way across I find him standing in the middle, a little shy, or perhaps coy, I don't

know, it was rather cute, whatever it was; and he says bye, he has to go, but here's my card, do drop in at the store, if ever you are in that area, I am open through the day, and with a straight look into my eyes he adds, and night. I think he got a little worried by that addition, and after a quick wave, he went away.

That was a disappointment, because I was hoping that he would have a car or a bike or something, and that he would be able to take me home. Now I have to take a taxi, and a woman smelling of alcohol does not make for a normal passenger. Anyway, so I too say my good-byes and ciaos, and then manage to reach home without incident. I stared at the easel for sometime, and my fingers twitched, but I decided that six large doses of Irish Cream is not a good state of body to start drawing on a plain canvas. I dislike these artistic types who can write, or paint, or compose or whatever they do, under the influence. I mean it is clear that one cannot draw the line one wants if the message from brain to muscle is like drowning in intoxicated blood, no? As for those who cannot do it except when intoxicated, well, I don't even think they are artists. They are just poseurs, who make money, or if not money, reputation, as radical artists. Take a look at their work, and you will notice two things, one, that there is very little work, and second, that which is there is rather mediocre, seen by itself. And the third type, who ruin their skills because of intoxicants, well they are merely drunkards, who sometimes are, or were, poets, or musicians, or sculptors, or very good friends. Anyway, my theories of art are not the issue here, no, I guess the Bailey's is making me theoretical now, and so I shall fall asleep, sleeping on my right side, because I must sleep always looking at the easel and the sometimes-blank, sometimes-half-painted canvas.

The next day, on an impulse, I did a strange thing. I went and bought myself a nice 10-speed bicycle, and started riding around town. One has to do this, naturally, before peak hours, which meant getting up early. As you know, there are not many bicycles left in this City anymore, everybody has shifted to those Japanese or Middle-European small cars. It was great, when I started biking early in the morning. It was as if a great despair had lifted itself, and was evaporating in the early morning sun. I painted in my mind, I painted the City itself in colours brighter than it had, in quick strokes,

breathlessly, as my legs pumped the pedals. I was painting the City, on round, meandering canvases, a whole series of them, and sometimes they turned round and round in two dimensions, making the perfect sine wave. A whole series in one day of Cityscapes, of biking wherever the roads and bylanes led me, to cozy little bungalows, a hundred years old, with, thank god, unkempt gardens with lots of flowers, to whole kilometres of matchbox apartment blocks, only straight lines there, vertical and horizontal, like some equation that only economics thinks of, not topology or even geometry. I mean only squares busy worrying at how to continue being square lived out there. Not even triangles. No solids at all.

It was one such morning that I turned a corner and saw this sign, "Drug Store in a Cool Dark Place." I was so pleased, I tinkled the bell on my bike. But the store was a little further off still, I don't think he heard. In fact, the store was closed. It had a good peaceful feel about it, and was a little more yuppie than I expected, I mean he has glass doors and a "Closed" sign hanging in the door. I didn't know where his flat was, I didn't want to disturb him either, maybe the guy had gone off to sleep just now, he had said he had insomnia, poor thing. His eyes did look sort of worn-out under that cool flash. Well, it took me three more rounds before I could bring myself to stop at his store, and I did that because the lights were on, inside all that glass. So I stopped, and tried the door handle, in spite of the "Closed" sign hanging inside. It opened, and a small bell tinkled somewhere, almost like the bell on my bike. I looked inside from the door and said, "Are you open?" And then I noticed him, standing in a corner, with a medicine box in his hand, and smiling, well, beaming at me. I blinked my eyes once because I saw him there like that, and it was as if I was looking at a Hockney painting—you know that strange way in which he does interiors—but with his face done, this time, not by Dürer, but by Schiele. Well, I guess he has a changeable face, like. Painters always find that attractive. Photographers too, I guess. I think he wanted to drop the box he was putting into the shelf there, and strut, well, maybe stride to me, but he looked away and coolly put the box onto the shelf and then slowly walked towards me, unconsciously wiping his hands on his bottom, which of course was well-hidden, because he was facing me, and he had this deep blue corduroy jeans on him.

And a nice shirt too. He came closer and held out his hand, so I took it with mine, warm from all that biking, his cold from sitting around in the store the whole night, body temperature lowering, lowering, all that while.

For a minute it felt as if instead of breaking, the ice was hardening, as I held his hand loosely in mine, smiling at him. But then this somewhat odd moment was shattered by a shriek from inside and that surprised me, and I must have made some sort of a frightened sound in my throat, and gripped his hand suddenly, because he too looked bewildered by that sound, but as I am looking around for a source of that shriek, he starts laughing because by then I have figured out that it is either a coffee machine or a pressure cooker. It would be very odd for a pressure cooker to shriek at such a time, it must be a coffee machine, or a kettle. And then, of course, both of us are laughing at my reaction, not to say unprecedented stupidity. So naturally he said, "You choose a wonderful moment to come. I actually can offer you coffee, and some breakfast." Coffee is always good for breaking the ice, especially after such a moment.

So there we are sitting at a table in an inner cubicle, and I am surprised yet again by the really good taste with which things are done up in here. There is a nicely made small round table with two chairs done up in blue cushion covers, and everything is compact and clean, and it is clear that he is used to living by himself, and has no difficulty with it. I have seen a lot of clean places (I notice them because my place is rarely clean and tidy), but this does not have even a hint of the clinical obsession with cleanliness that singles often develop. Everything is nice and cozy, and in its place in a homey sort of way.

He offers me, I mean he puts on the table, hot strong coffee (instant, though), a loaf of fresh bread, sliced already, with deep brown crust around pale white slices, a bottle of strawberry jam, a bottle of marmalade, and two boiled eggs. He puts a white plate before me, and takes one himself. Now the eggs are interesting, because obviously he was to eat both the eggs himself. Unless he is going to eat them himself without offering me one, nevertheless. I like hot boiled eggs in the morning. Well, sort of.

So we are making conversation just to stop the ice from hardening again, and I am looking at him intermittently, noticing that he is really beaming at me when he thinks I am looking away. I don't know, but perhaps he thinks I too am beaming. All this noticing makes me ravenous, and just as I am about to ask him if I could have an egg, he finishes shelling the first one and puts it on my plate without saying anything. So I had not noticed that he had already shelled an egg. All the colours there, of the breakfast, are beginning to make me feel a little giddy, especially the clear, irreproducible white of the inner sides of the eggshell. I am normally not afraid of whites, but this time I found it rather disturbing. So I cut open the egg, and look at the reassuring yellow of the yolk instead, and he realizes that something is happening and stops making conversation and concentrates on his breakfast instead. I finally got myself under control in what seemed then like a riot of colours, in what could only have been a normal breakfast of bread and boiled eggs and jam. This happens to me sometimes, colours attack me in strange unexpected ways. When I look at him again, he has gone all cool, not beaming anymore, and before I know what is up, I have said bye and thanks for the breakfast and I am already on my bike, heading home. The ice hardened around me suddenly, I guess.

A week or so later, I made another attempt to get in touch with him, but this time, I decided that we should first talk on the phone, so I rang him up, and after a few lines of conversation he asked me to dinner, so I said, yes of course, when and where. Over that dinner, we merely talked about our childhood. A safe subject for me, because I did not want to tell him yet that I had cancer. I was beginning to get worried about telling him, the how and the why of it, especially the how. I mean, he was nice and cool and all, but one never knows when people will shy away from oneself, especially if they come to know that you have got a fatal disease.

The next dinner I initiated, of course, and ate so heartily and so much because he was finally feeling comfortable with me, and I was too, except the issue of telling him about my cancer. That second time, he said, well, sometime you must come home again, and I agreed. But the next dinner we ended up in a restaurant again. By then I had decided that I would tell him as soon as possible, to avoid any unpleasant surprises later.

So here we are, a few weeks later, and he is trying to figure out how to tell me that he loves me, and I am trying to figure out how to tell him that I've got cancer. So as I order some nice strong coffee, it's already ten in the night, and it's time for medicine, and I absolutely don't know how I am going to be able to slip in the tablet into the coffee cup and drink it without him noticing, you know? I mean this is the first time we are together at this time, and he has not yet seen me take any medicine at all, right? I mean I have been careful. And, he is a pharmacist himself, so if he looks at it, he will know right?

So maybe that's how I should do it, put the strip beside the coffee cup, put in the tablet and his pharmaceutism, you know, will take care of the whole thing.

That's exactly what I did. I was nearly shaking all over by then, I mean, if he finds out, then he just might choose slowly to detach himself from this about-to-be-formed attachment, right, and embarrass me further by trying to be as unoffending as possible. I mean, come on, there's stakes here. So I fished out the strip, put a tablet in the coffee, and put the strip beside the cup, and picking up the cup, I tried to look thoughtful, and stared at the traffic through this glass window in this high-up restaurant. His natural curiosity, and his knowledge of pharmacy got the better of him, I could feel him struggling with the possibility, but he finally picked up the strip and read the name. I can see his reflection in the glass, but it doesn't tell me what he's thinking, but I decide not to look at him. Then I hear him say,

"Fuck me, you've got cancer too!" And then I look at him sharply, and he, like, looks straight into my eyes, and I know that he is telling the truth, so I too say, I mean, what else does one say at such Absolutely Cupid moments, right, and don't bother about rhyming, dear poets, so I say, closing my eyes like blind,

"Fuck me, too!"

And then we are both laughing so much that I knock the cup over, and in trying to catch my elbow before I do that, he knocks his glass of water, and then we are both spilling all over the place, like, with laughter.

That was, what, a year and a half ago. Two months into this, I moved into his house, and started looking after the store whenever

he felt sleepy. We put lots of prints on the ceiling, Cézanne, and Redon, and Evgeny Patchowsky (that entirely because he liked it—I find Patchowsky a little too emotionally experimental, like), so that he could look at them and hope to fall asleep, yes, I even let him put one of Old Sunflower there. He tried to teach me his pharmacy thing, but I can never manage, so we got a storage programme, and now if I don't know where the medicine a customer is asking for is to be found, I just punch a few keys in, pretending to find if we have it at all, and then I instantly know where it is and go and get it, all Ms Efficiency. I am not like that at all, you know.

I tried to teach him painting, but thrice it ended in love-making, so we decided to skip the teaching part, and get down to love-making straight. We are free, you see. And, yes, I almost forgot to tell you. Once we had a Serious Discussion of Our Cancers. See, I am not bothered by it, but he is younger, and sometimes it disturbs him because it disturbs everybody around him, right? It was in that discussion that we realized that we simply did not want to take serious treatment, like. His hair, you see is very soft and straight, and long, so as I was looking at it, I realized that I did not want him to have a series of chemos, like, and lose all that nice hair. I was already inclined not to have chemos, or any other treatment. So when he asked me what I was thinking of, I told him that I will feel very sad when he lost his hair. It suddenly struck us both that we did not want to be treated. What we had found was too precious to us. And in any case, as everybody knows, one might die anyway, with or without treatment. And I for one did not have the money, and neither did anybody around me have money of that kind to spare. We would have to sell his store, and we did not want that at all.

This was thus, a pact, the only solemn and formal agreement we sealed with an embrace, that we will not take any serious treatment. I think that was the only time we held each other with an emotion other than sheer lust. We were perfectly capable of looking after each other and ourselves together. That's why I told you that we were dying. We know it, because we chose it. It seems like a minor victory over death itself, choosing to die in this particular way, in love, and not in any other. In any case, I never understand all that my doctor explains about cells and their growth and all that. I tell him,

hey, it's okay, it's okay, it's very well known we are going to die, no? So what's the big deal if we decide to do what is to be done anyway, isn't it? I mean I've got choice, so I will exercise it, right?

That was, what, a year ago, and already our cancers are taking different paths of development. His has taken an exponential path, mine, the path of physical pain. He feels warm all the time, so we have got AC in our bedroom, and I find it a little cold, so I sleep with blankets, he, almost naked. Sometimes, if I moan in pain—this is a pain that one feels deep inside the bones—he gets into my blanket and holds me tight and I cry on his still muscular shoulder. Oh I should tell you that we do heavy work-outs in the gym, because we do want to live healthily, so he is more muscular than when I met him. Also, I have been painting a lot, and sometimes I get all dizzy because the colours attack me nowadays with greater ferocity. I might even get the Schiele red sometime, I think, before this year ends in a few months. I am also selling a lot, because the news has spread that I am dying, and refusing treatment. I dread the day when some bag-swinging journalist will come with a recorder and interview me. I have read something like that once, some famous writer, see, he is dying, so naturally the public wants to know what it feels like to know that you are dying for sure. I think I will throw my palette at her if she ever comes, the journalist I mean, of course.

His cancer is turning worse, and his veins are breaking apart. Mine will soon turn more painful, with a constant ache in the body. It will then become increasingly difficult to paint. We are still refusing treatment. We love each other too much.

Yesterday, we witnessed the first splotch of blood on his skin. It was on his chest, the vein broken, and the blood slowly seeping just beneath the skin. He had just had a bath, and the blood under the brown skin made a very strange combination. I bent a little to kiss that splotch of blood, and before I realized what I was doing, I had bitten him there, and there was the taste of blood in my mouth. It was very erotic, very vampire and Goth, and we made love with an unfamiliar intensity. Afterwards, he gave me a very long and soothing massage to relieve my bone ache. He fell asleep as I was having a bath, and when I saw him there, naked, on the bed, asleep, vulnerable like a child, I turned away, and went back down to the store to attend to it.

Later I sat down to paint him like that, and found myself doing a little better than Hockney, or Spencer, or Patchowsky. And I did something that very few people do nowadays. I did him in colour, of course, quickly, giving him a cool and dark blue bedcover to sleep on, and to bring out that lovely brown of his skin, and the pink of the soles as he lay there, face only half visible, his chest and bottom and thighs taking up large parts, and the thing I did was I did an outline to him. This is an ancient technique really, and produces the most stunning effect of precision and softness, an impression of delicate artistry and draughtsmanship beneath and around the handling of colour.

He came down as I was doing his left eyebrow, beneath the highlighted slope of the forehead, partly covered by his arm. I did that with a comb, actually, and it was very strange to do it that way, because it felt as if I was really combing his eyebrow. What one does is one applies very dry paint in the shape of an eyebrow, and then one takes a comb, a very small piece of a very fine comb, and one drives that through the colour, and that leaves a very fine impression of shaped hair. He stared at the painting for a long time and said, "This is your best." He has seen me work all these years, and knows what I can and cannot do. But then he said, "I didn't realize that you loved my bottom more than my face. Or anything else!" I tried to protest, but he had already burst into laughter. That was when I realized that the title of the painting was: *Watch Me!*

He sat down while I added some colour here and there, just giving the picture a more finished look. But soon he started feeling warm and sweating, so I went with him to the bedroom, and made him sleep for some time. As he took his shirt off, I saw several splotches of blood on his back, and I held him close from behind, pressing my pelvis into his bottom, held him hard, kissing those splotches. But I did not bite and suck his blood. I don't need to anymore. I already have him stored in a cool dry place, the bedroom, while he is alive, and my love, after we are dead.

❄

Nurse Phi, the Electronic Rembrandt

Nurse Phi never said anything to anybody, because she could not speak. She could not speak because when she was a child, the accountant and the store-keeper in the orphanage raped and tortured her, and as they did that, they damaged her larynx. The City did not worry much about her larynx—it was more worried about vaginal and anal damage, whether she would be able to conceive after she grew up, it was worried about her mental stability. The accountant and the store-keeper were brought to book, and spent six years in an Improvement Centre. That did not improve Nurse Phi's larynx, but the City, the policepersons, the judge, the media reporters and anchors, the viewers and the readers, and naturally all the Social Service People (who had organized several rallies for justice) congratulated themselves on their ability to maintain justice in the City. The City was always proud of itself, always did things that made it proud of itself.

Nurse Phi, for reasons unknown to most, always signed her name as Phi Cash. She never told anybody, in writing, or through sign language, why she called herself Phi Cash. But once, when a deaf-mute patient came under her care for a month, she talked to her a lot, and the patient, another young girl who had been badly beaten up by her equally deaf and mute lover, asked her how it was that she had such a strange surname. Phi explained the last name to her: she came across this word when she herself was in hospital, recovering from the various injuries that the accountant and the store-keeper had inflicted on her, and one very sensitive, very wet-eyed Women's Rights Activist used this word for her. It meant Child Abuse Survivor Hero. Phi liked the sound of the expanded form, especially the hero part, and liked the irony of the short. Phi was not really a CASH, she knew. But she was rather young when she was raped, and she liked to think of herself as a hero anyway, considering that she was alone in the world since she was perhaps two years old, and had survived, until the torture and rape, reasonably normal.

Phi was a tough person. You did not mess with people like Phi. Once when a patient tried to put his hand up her pure white skirt, she moved back, took a scalpel from the table, and made that universal gesture, sticking out two fingers towards the patient, and then pointing them at her eyes, "Watch me!" She came up near the patient, on the other side of his bed, and where the life-saving drug tube was inserted into his left wrist, she put the scalpel near the soft plastic tube and pretended to press. The patient went red in his lecherous face, and seemed to have a heart attack, but Nurse Phi merely stared hard into his eyes, and walked out after adjusting the dosage in the drip. The patient tried, later, to complain animatedly to the authorities, but Nurse Phi possessed such an impeccable record that even the authorities figured he was lying. They merely smiled at him and discharged him earlier than they would have otherwise.

Phi had been a nurse for the last eight years, and had come to like it. There was a clockwork-like mechanicity about being a nurse, especially to the smile, and she was particularly addicted to that mechanical smile which everybody else thought brilliant, endearing, healing; including other nurses, who tended to be a little envious of Phi and her smile. It was almost as if they thought that her history had given her a special access to niceness, and brought a basic human side to her personality. That is how, at least, they tried to explain Nurse Phi's extraordinary smile.

Other nurses, envious as they tended to be, were also curious about her as a result. But Nurse Phi's inability to speak protected her from their curiosity, and she never invited them to her apartment, not even the doctors. The doctors learnt very quickly that one left Nurse Phi alone. Some of them found her half-broken and later badly-put-together nose very erotic, and tried to stand close to her, or put an arm round her, but Phi always saw it coming, and quickly moved away. For moments and people worse than these, Phi had a special remedy. She always fastened her nurse's cap with a very long, thin and very sharp pin, and all she did was to drive the pin into the man's biceps an inch deep or so, and then the worst moment was over, and such people immediately became better than they were. After that she even dressed the wound herself, smiling kindly at the man, who felt worse than castrated by that minuscule but excruciatingly painful wound.

You did not mess with Nurse Phi, the word spread soon. Eventually, the younger and newer doctors were always told not to mess with Nurse Phi as a part of their induction ceremony. Neither did Nurse Phi mess with herself. She no longer needed to pretend to be someone other and better than she was, hell, she no longer needed to pretend to be herself even.

Nurse Phi's greatest asset, and therefore her weakness, was her washing machine. Her white dress, and the extraordinary brightness of her smile were always clean and pure. Of course, Nurse Phi knew washing machines from her childhood. But she bought this machine for herself, paying installments for one year. It was one of those machines that some companies produced for older people actually, hoping to make money out of the nostalgia for younger days when most machines were primitive, or less complicated (depending on how old you were). This machine did not have a remote control, or an analyser. It was, again, top-loading and rather large in that old-fashioned awkward design which was a retro version of retro designing. It had a retro, pull-out soap dispenser. It warmed the clothes and dried them. It was real, and it fascinated Nurse Phi while she used it, which was always before going to bed, folding the clothes too, so she always woke up to cleanly folded crisp clothes, which, thankfully, were not retro.

When she was not on duty, Nurse Phi studied animation. She loved the cartoons, she always wanted to make funny films with nice cartoons in them. In the animation studio, of course, she was not known as Nurse Phi; they did not know she was a nurse. They knew her only as a slightly slow and stubborn student, Phi. Nurse Phi had been studying animation for two years, but the instructors were not happy with her because she could not sketch things with the finesse that Japanese industry standards required. Her cartoons were always too cartoon-like, her imagination too imaginative, and the stories she devised too obviously story-like. Sometimes the instructors worried if she was slightly mad—mad, as in out of touch with reality as they knew it. While she sketched, for example, they saw what was a grim look on her face, her tongue sticking out like a child's, but the eyes and the chin set in an expression which could only be understood as fury. The expressions of most other students were copies of the

expression they were sketching into the faces of their characters, but Phi's cartoons were always only having fun, while Phi herself looked furious. The instructor for script-writing once tried to tell her that her characters were always having fun, and that was not what life was like. He was confronted with a look of total incomprehension. After that, he stopped trying to tell her that her characters—mostly bunnies and pixies and talking trees and extraordinary birds which could not have ever flown—were not what the potential producers wanted.

The draughting instructor, who supervised technique, had sufficient reason to be pleased with her, but agreed with the scripting instructor that Phi was not going anywhere as an animator. She was pleased especially with Phi's use of colour and line. Phi's colours were always innovative and attracted the eye. She never used primary colours, as was the fashion amongst animators, but mixed colours with some secret recipe, almost. These tended to be mixtures of yellow and blue. The faces of her cartoons were always clearly drawn. So clearly, in fact, that apart from Phi no one realized that each and every face that she sketched had at least one element from her own face. Jackie the Bearded Wolf Without Moustaches, for example, had an upper lip which was an exact match of Phi's upper lip, and Gondieleaf the Tree Girl had legs which were Phi's. Once Phi created a character called Branchum Shindyglass, and she made her hair exactly like her own, but tied it up with a beautiful silky ribbon that flowed all the way to her waist, so that nobody noticed.

For off-duty time, Nurse Phi had three basic designs of clothes. She had jeans and leather jacket, and jeans and leather jacket, and jeans and leather jacket. These three basic designs came in three sets of colours: black jacket and blue jeans, blue jacket and black jeans, and black jacket and black jeans. She never liked wearing blue jacket and blue jeans. Off duty, Phi was a grim person, and did not socialize much. In fact, she could not even remember a time when she had drunk or eaten with a group of people. She always ate alone at a café.

She routinized her food in a systematic way. She always went to the same café for a month—unless, of course, the café was turned into a gaming parlour (for uptown kids) or striptease club (for downtown Executive Sleaze) during the month. She could always tell when this was about to happen by the quality of coffee.

The coffeeness of the coffee began to diminish, the foodness of the food, and finally the caféness of the café, and then the café closed down for a day. When this happened, she always made it a point to visit the area in the next few days, and observe from some other café the progress of the change-over. First, the machinery was auctioned off, and all the car-owners came and bought it up. Then the furniture was re-cushioned (who wants to buy new furniture to start a gaming parlour or a strip club?) in exactly opposite schemes of colours, and the café was re-painted, and finally the sign-board went up, and in a few minutes you heard music, or the robotic sounds of "You are dead the third time. Game Over, newbie." And you could see a smiling cashier counting the money. They always put the cashier behind glass (bullet-proof, but how many people without guns can distinguish between glass and bullet-proof glass?), because that reassured and attracted the potential customers—it was good to see a cashier counting money, it meant that it was a good place.

But if the café survived the whole month, on the last day, Phi went up to the kitchen, and told everybody there that their food was very tasty, and never went back there. Only once in eight years had Phi seen a café change into a café all over again. She found the phenomenon really astonishing, and that was the only time she ate in the same place after the month was over. But, of course, it was not really the same place.

Naturally, Phi knew a lot about cafés and eating places, and consequently, she knew a lot about people, since it was understandable to find people where there is food. She knew a lot about people and their gestures and expressions. She did it dutifully because she was an animator, and animators always took expressions from people and stuck them onto their characters, even if the characters were not real. Phi was, in fact, far more curious about the reality of the expressions on the faces of real people. She particularly studied the body-postures of people, and devised a typology on that basis. There were some who always bent over their plate of food, and ate slowly, concentrating on the slow progress of spoon to mouth, with a slight frown on their faces. She called these the Cup-and-Gap people—these always gave the impression that they were worried that the morsel, or perhaps the spoon itself, would disappear before it reached their lips. Then there

were others who ate very quickly, rarely looking at the food after they verified the contents of the plate. These were the Cops-and-Thieves people. They were always worried that somebody might take away their food.

Then, there were the Lookers. These were usually female persons, and ate with a daintyness that was deeply spiritual, because they were interested more in what they looked like while eating, rather than in the food, or in its taste. They admired themselves because they knew that it was very difficult for anybody to look beautiful while eating.

Nurse Phi's two lives, on duty and off duty, were distinct from each other, and she never ceased to wonder how she never met people from duty time in off duty time. It was, she concluded after long consideration, a curious statistical phenomenon. She had learnt at school that all such phenomena were curious statistical phenomena. Nevertheless, she wondered how the traffic policeperson at the corner never came into the hospital, or the thousands of waitresses she had seen in the hundreds of cafés she had visited never came into the hospital for anything. Not even for a second-opinion pregacy test. Nobody she knew off duty came into the hospital even with a minor injury. Neither did she meet any of the nurses or doctors anywhere on the street or in the cafés, or in the animation studio. She was sure she would know because she knew hundreds of faces by heart, and knew the various expressions they wore, in their own specific ways, how they would look if they were hurt, or wounded, or happy. She was, after all, an animator.

What interested her most was the difference between the expressions on people's faces, and the stories that their hands, or feet, or shoulders told. There was one Looker she remembered especially. She was not a mere Looker, she was a Stunner. Every part of her face, when analysed separately, was perfect, but unlike mere Lookers, when after analysis these parts were put back together, the resultant totality was perfect too. The Stunner had stunning clothes. Ethnic African in design, but ethnic Indian in material, she had found the only design that actually was capable of subduing her body. The Stunner also had a stunning smile, naturally. It was, in a sense, the

exact opposite of Phi's own smile. But, as Phi looked on, she noticed that the hands and fingers and the back of the hand had some other stories to tell. The right forefinger and thumb, for example, were tightly twisting the fastener of the stunning bag with its strap so elegantly sloping towards them from the left shoulder, over the left breast. The Stunner clearly did that all the time, because there was a small dark patch of calloused skin on the right side of her thumb. It was looking at her that Phi thought of Branchum Shindyglass, the character she donated her hair to, but tied it with a long silky ribbon so that nobody noticed.

Then there was an Executive Sleaze who had walked into her café before it changed into a striptease club. This Exec Sleaze was, like most of them, unbearable to look at, with a rounded but tight jaw, and like most of them, he spoke as if he was biting off bits of air too thick to breathe, and he ate as if he was eating the core of a nuclear warhead or something equally expensive, reluctantly. Now, the hands and fingers of this Exec Sleaze were stunning, because though the skin was soft, the fingers were stiff, so that they looked prosthetic. The Exec Sleaze, sharp as most of them, felt Phi's eyes on him, and looked up, and smiled so brightly and nicely, that Phi was mortally frightened, because Exec Sleazes smile only when they see Profit, and Phi did not like to be thought of as Profit, or Freebie. When she sketched in a character the next day at the animation studio, she took his face, but decided to be kind, and gave him yellow hair, so that he looked like Tarzan with Yellow Hair. She dressed him like Tiger Man, but with a head-band which said, "Unfit for Profit".

For another year, Nurse Phi and Phi lived their distinct lives, always exchanged at the door to her apartment. It was late in the ninth year at the hospital that these distinct lives broke into each other.

Her café was changing into something, but this time, Phi could not predict what it was changing into. That made her curious, and when it closed down, she chose another café close by, as was her habit, and kept a watch for three evenings. On the third evening, she saw some youngsters, some of them with yellow hair, go in there. Soon, there was loud music playing. Phi got curious and paid for her food and went out. As she walked towards the music, several police cars arrived, without any announcement, and one of them stopped

right beside her. Phi did not pay any attention, because it was clear that the police did not want attention, and walked towards the music. But before she could reach the door, the police, four of them, reached the door, and two of them had guns in their hands. She thought she would speak to them, but as she was about to speak, a fifth policeperson knocked into her from behind, and she clutched at air in pain, instinctively, and all hell broke loose. She regained her balance only to find the policeperson holding a gun to her head and telling her to shut up, and she could hear gun-fire.

One of the youngsters jumped from a window, and landed right in front, and screamed in pain because she landed on her wrists, and Phi could hear the crack of the fracturing ulna. She showed the policeperson her identity, that she was a nurse at the hospital. The policeperson, still a little disbelieving, pointed the gun at the fallen girl, and told Phi to go away. Relunctantly, Phi left the scene of crime, which is what it was presumably, went home and went back to the hospital for the night shift.

Checking the patients, she found the youngster, the girl from the scene of crime, in one of the beds, her forearm plastered neatly, but her clothes still unchanged. Nurse Phi felt a little giddy at this singular event, this naked singularity, and for some reason, she felt like weeping in joy. She talked to the girl, asked her what happened in that abandoned café, but the girl did not say anything for fear of something, or because she did not understand Phi's gestures.

Late in the night, Nurse Phi decided that the sleeping girl needed to change, because she suddenly realized that the girl's face looked as if she was having her menses, woke her up, and gave her a hospital gown. The girl put it on reluctantly, but thanked Phi profusely as she helped take her shirt and jacket and jeans off, and thanked her for the tampon. In the morning, Phi took the girl's clothes with her, and neatly washed them, with great care to remove the blood on the jeans, and the white stains that the jacket had. As she stood there, looking at the clothes swirling in the washing machine, she felt an inner glow in herself, cleaning the clothes, and folding them up, still warm from her washing machine.

She took the clothes with her to the hospital in the evening. When she reached the girl's room, there was an Inspector talking

to the girl, and two other policepersons standing beside the girl. Nurse Phi smiled her bright and healing smile, and gestured to the policepersons to leave because the girl needed a change of clothes. The Inspector noticed the clothes she carried, and seemed to have a heart attack, merely looking at them. His eyes bulged. After a few minutes of stunned silence, the police told her that she could be arrested for destruction of vital evidence. They were not nice to her. The Inspector, whose eyes were still bulging, and whose face was still red as if he was having a heart attack, told her it was stupid of her to wash the girl's clothes. As she moved away, he gripped her arm tightly. Phi moved into him, unfastened her nurse's cap, and stuck her thin sharp pin into his flabby biceps. He screamed, let her go, but as she ran out of the door, the other policepersons grabbed her from behind. After she could struggle no more, they finally put handcuffs on her, and charged her, there and then, not with destruction of evidence, but with obstruction of police officers in the line of duty. Phi stored up the Inspector's face in her memory for sketching in later, already giving him, as was her habit with real people, a part of her own, but this time it was her own furious expression that she donated.

The Bicycle Boy and the Vendor of Variables

The Bicycle Boy and the Vendor of Variables had a long-standing arrangement, which made it possible for the Boy to collect his lunch sandwiches from the Vendor, and made it possible for the Vendor, in turn, to collect variable items that the Boy encountered on his daily journeys. This arrangement had been in place for almost two years now. It was about two years ago that they first met, and those who do not know their histories, independent until then, would never understand how they could get along. Because the Bicycle Boy was regular like clockwork, whereas the fare the Vendor offered was variable, often changing from morning to evening.

The Vendor of Variables had been, once upon a time, a stockbroker, and he was very good at stockbroking until he made a mistake once, and lost his credibility, money and deposits, and was forced to sell off everything except his apartment. His wife left him soon after, and a little after that, his only daughter went off to a university, on a scholarship, a university as far away from him as possible. After that it took a lot of nerve for him to get back into any kind of business, and even today he took part only in businesses that had nothing to do with names and numbers that scrolled across TV screens, computer screens, or overhead displays in the financial parts of the City. And he hated acronyms of any kind, and brands, of any kind. He only and strictly dealt and traded in plain objects. He got along with the Bicycle Boy because he liked the Boy when he first met him, they seemed to speak the same language, despite the obvious difference in age.

"So what do you do, kid? Just roll around on those tough wheels through the City?" he had asked when the Boy had first stopped to buy a sandwich around noon.

"Yes," the Boy had said, "I am the City's only lonely trailblaster. I have come back from the traffic, and I have seen it all, and I remember it all."

He was about seventeen then, but did look as if he had really seen it all. He probably could tell each part of the City by the type of dust on people's shirts, or tell a car garage from the car. He had a calm and inquiring face, though he must have been weaving through murderous and often automated traffic of cars, cars, and cars, through the day. His eyes had not lost their smile yet. The Vendor, who had smiled through the wreckage and overhaul of his life, could empathize with that. That day when the Boy's perambulations touched the rather straight routine of the Vendor's movements, tangentially at that point in space, he had filed the Boy away as an interesting variable. They met regularly at that point after that, with a variation of a day or two, but not even for a minute did the Vendor think of the Boy as a constant. Soon the Boy was only a variable caught in a loop of repetition, a loop for which there was definitely a limit, perhaps undefined in itself, and certainly not known at the moment.

The Bicycle Boy in turn liked the Vendor of Variables because he never turned up the same sandwich twice, within memory, voluntary or involuntary. Every time, the Vendor had something different. The Boy liked that because that fitted the ever-changing pattern of traffic that he saw on his compulsive journeys through the City. He never liked constants anyway. He did not, for example, like the VP of the Coca-Cola Franchise, who was constantly and essentially dressed in a grey coat, and a Coca-Cola tie as he got into his Coca-Cola coloured-and-sponsored permanently new Mercedes, and he did not like the VP's chauffeur either, who was permanently dressed in fresh white, and who turned the car along the curb with the same calculation of torque, force, and velocity. In fact, the Bicycle Boy powered his cycle in the grooves that the heavy Mercedes had made over the last year.

The Boy had a head for topology, geography and geometry, he knew all the streets in the City, he had seen it all, and he remembered it all. The street map of the City was by now hard coded in the circuitry of his brain and calves and foot muscles. Sometimes when he needed more money than his habit, the Boy acted as a tourist guide. He had managed to build a reputation amongst the Taxi-Drivers, because he knew the City better than them, and whenever they had passengers who booked in advance to go to places that they did not know, they called him up on the wireless which, in fact, the Taxi-Driver's Informal

Union Manager had given him. Through the Taxi-Drivers, his reputation had spread also to the Car Hire services, who recommended him to the snobbish Exec Sleazes who wanted to drive their own fast thrumming cars when they came into the City, but did not know their way about in it. So sometimes the Bicycle Boy had to sit in these luxurious cars, pull the seat belt around himself, and instruct. He never said anything but "Left, after three minutes at this speed." Sometimes he also had to instruct chauffeurs, when the Exec Sleazes smoking or drinking on the back seats were taking a look at some ramshackle house, or abandoned apartment blocks. The City was large, a Business City, and it was common for the boy, though not frequent, to be talking on his wireless on his shoulder, issuing instructions to car drivers, Taxi-Drivers, while he cycled through the City, weaving and weaving through car traffic, his 10-speed cycle dominating, like a supermodel dominating a boring catwalk. Endlessly, compulsively.

It was not clear if the Bicycle Boy had a family. It was not clear to him either. He lived with a middle-aged couple, both halves male, and he was reasonably sure that one of the halves was supposed to be his father; but he was not sure that he himself had come out of a female womb. There was no trace of anything feminine in the house that he lived in. Actually, he was in the house for so little time that he wouldn't have known anyway. He was always woken up by the other male, with a sharp, peremptory knock on his door, saying, "It's time, sweetheart!" and when he went out after getting ready, putting on his bike gear, there always was something to eat on the kitchen table—mostly cereal and milk; but sometimes the man made wonderful things, you couldn't even call it food, the names of which the Boy did not know, and could not pronounce when he asked and was told. The Boy had concluded long ago that the man was a chef in some big restaurant, and could not make himself prepare any interesting food unless he was being paid for it. Such interesting things he got were from the previous evening, or morning. He knew, naturally, that the man was gay, and his father's partner of rather long standing. They all lived in the house like strangers to each other, taking care of each other only when needed.

In any case, the Boy was not terribly interested to know anything about his father, or his father's partner, or his presumably

non-existent mother. After a few minutes of trying to think about it, the Boy would get bored, and start seeing his front wheel eating up the streets behind a Ford, or a Lexus. When he was younger, and before he started biking, the Boy used to have friends. But now, the memory and meaning of being with friends had become very dim in his mind, and he assumed that everyone was like him, liked being by themselves. In those days, the man he knew must be his father had tried to make him go to school. The Boy had willingly given it a try, though he hated every moment of the trying. What he remembered, though, was the journey to school, in the school bus, passing over the N-BAR, and once seeing the Bridge Man. In school, though his teachers of topology, geography and geometry were very pleased with him, and wanted him to take Special Training in Talent for A Subject Programme; he was diagnosed by an enthusiastic Psychology Teacher as having not only Asperger's but also Autism, and a need to be sent to an S^3P, condescendingly explained as a Special School for Special People. The father and his partner ruled out the idea in the presence of the irate Psychology Teacher, who went away mumbling about the need for psycho-social adjudication and training, and his own PhD.

In any case, the Boy was old enough to insist that he was old enough to ride his bicycle not just in the parking lot, but in the City traffic. After that, naturally, nobody thought of sending him to school. In fact, nobody could. He became the Bicycle Boy, and eventually, everybody knew that he was.

The Vendor, on the other hand, had a clear memory of his earlier life, and sometimes missed caring for things like family, daughter, and physical comfort. In the apartments he lived in, he was much trusted. Being much older than the students who got a kick out of living together still, his were the shoulders that were much cried on. Young girls worrying about pregnancy, boys worrying about being sexually inadequate, or plain unsatisfactory to their either-gendered partners, kids with math problems, single women going through the mandatory separation from their much loved earlier husbands, single men worried about not making as much money as they wanted, literature professors not knowing whether they were doing well, all sought advice on this personally intense matter or their own hard-won emotional lives. The Vendor was always available before he set up his

stall—never in the same place, but always on the same street—and toward nightfall.

The Vendor had arrived at an agreement with the police about the street, which, unknown to him, had led to high-level disputes between the Traffic Branch and the Crime Branch. The Traffic Branch did not want his rather mobile stall anywhere on the street, because that caused Parking Problems to all the middle-level business organizations. The Vendor, mindful of what matters, had made his arrangement with the Crime Branch. If he noticed anything unusual, he would report it to them. This was useful to the Crime Branch, because they knew that this middle-level business street was often used by criminals to set up dummy business firms and really comfortable offices. It had all begun one day when a café had shut down, and then it did not change into a new café or gaming centre. Two days later, in the evening, he saw the police arrive, take out their guns and storm into it. He had seen a policeperson shoo away a woman, dressed in black jeans and blue jacket. Then he saw a girl jump out through a window, and a policeperson nab her. After the arrests, after the police had gone away, the next day, an officer came and talked to the Vendor, asking him about the street, the various offices there and what used to be the café. The Vendor insisted he knew nothing. The officer asked for his papers, the permission to sell things on the street on a mobile platform. The Vendor said of course he did not know that he needed permission to do business. The officer—an Inspector—came back the next day, but this time he knew the Vendor's history, and had come to like it. So he was nice and gentle, almost affectionate, and asked him to keep an eye on things generally, and that he would not be bothered about running his stall.

The traffic policeperson down the square naturally did not like him, and wanted him to go somewhere else. The Vendor argued with him or her periodically. But this time the policeman threatened to book him for violation, encroachment and report him to the municipal authorities as well, who, he said, would take away his stall and every variable that he sold on that day. This made the vendor very angry. He told the policeman to go talk to Inspector, Crime Branch, who had authorized him. The policeman mocked him, but left soon, and never came back to harass.

What the traffic policeman did, in fact, was to go to Inspector, Crime Branch, only to be told not to bother the Vendor. He was a loyal policeman, but he was more loyal to the Traffic Branch than to the Crime Branch, so he wrote out a report, mentioning these things to Inspector, Traffic Branch; stating that he had been prevented by another police officer from carrying out his duties. The Inspector, Traffic Branch took this as a personal affront, specifically by Inspector, Crime Branch, and reported to his superiors in turn. There ensued a battle between the two branches, which finally, the Crime Branch won, but not without several transfers, and a few promotions in the Traffic Branch. The Vendor, naturally was unaware of all this.

He was, as usual, engrossed in collecting variables, which he did on Saturdays and Sundays. He collected variable items, initially varying from *Acanthus* flowers to *Dare*U! Posters, from Exponential calculators, to Hire-Purchase Manuals, Holga cameras, from Intelligent Books, to Love Positions Illustrated, from music to old Power PCs, from Quantums to TouchMe Toys, UV Binoculars, wicker baskets, Xirecom disposable cameras, and old Zoetrope studio DVDs. But soon he realized that he was totally over-determined by the English alphabet, and learnt how to randomize his collection, to make it truly variable. By the time he met the Bicycle Boy, he had managed to totally randomize his collection, because he had abandoned all systematic collecting. He had realized that things as they happen are random anyway, things as they came to him were truly random, more than any random-number generating system he could devise.

So he started visiting several houses in the area, on Saturdays and Sundays, and ask if they had anything to sell. Over the years, everybody came to know him, and he had little difficulty in buying variable items from grandmothers, middle-aged housewives, young children who wanted something he had, and men who wanted newer models of gadgets. His collection was an impressive one, and he could choose what to sell on a particular day. On his cart, on the day the Bicycle Boy stopped for a sandwich, he was selling

1. Thousand Island Spice, 1 Bottle
2. Old battery-driven car fan, 1
3. Zoo-tropic toy (changed from bear to bad wolf if

you touched the belly-button), 3
4. Zeiss Ikon lens, 5 mm, without case, 1
5. Hand-saw blades, various grades, 5
6. Screwdrivers, (Phillipshead), 7
7. Old copy of *Old Wives' Tales*, 1
8. Nude *DareU!* Posters (top one neatly folded only to hint at nudity)
9. Quantum Mechanics, Classical, textbook, 3 copies with notes
10. Shaeffers pen, 13
11. Digicam cases, worn-out, 2
12. Fresh HomeMade Sandwiches, 17

For the sandwiches, he always carried a small signboard, neatly painted by the daughter of the mother who made the sandwiches, "Fresh HomeMade Sandwiches". He also had a sign which he sometimes displayed, which said, "Clothes Pressed HERE," but nowadays had stopped displaying it, because most people did not realize that it was that sign which was for sale, that he did not press clothes. Many people in his apartment block sold him things regularly, and often he bought them regularly, because sometimes, at random moments, he thought that if everything was done randomly, then the randomness of collecting becomes predictable—the content of what he collects would still be random—but the act of collecting randomly had become predictable. In any case, this cherishing of randomness was a residue from his earlier life, which he had spent rationally buying and selling randomly fluctuating stock. It was thus that he settled for variables, rather than random items.

Sometimes, because he thought he would get a kick out of it, he went into a supermarket and checked how things were organized and sold. It was always a dizzying experience, often unpleasant, seeing these items neatly arranged vertically and horizontally. On his cart, he never arranged things vertically. He always allowed the buyer to look down at things that they were buying, and knew that that was the chief charm of his kind of selling. In the supermarket, sometimes you had to reach up to buy something, usually shaving cream, or condoms—an entirely unnerving thing to have to do because he

always wondered if 1) would he bring the whole shelf down? and, 2) buying had come to mean reaching up to things.

Soon after meeting the Bicycle Boy, he offered to buy things from the Boy, provided that they came from various and always different parts of the City. The Boy was game, and the first thing he brought was the wing mirror of an E-class Mercedes. He bought it, remembering how before he got broke, he was about to buy a Merc for himself and a neat little Ford for his neat little wife. The mirror looked quite new, and he wondered if the Boy had not relieved some Merc of this accessory. But he was not particular about his sources, and he was sure that the owner of the Merc wouldn't come looking for the mirror. He probably would buy a new Merc because the one he had was missing a mirror. He wondered if the mirror itself would sell. But it was picked for a neat 150 by a student who was going out camping on some beach, and said she would get a very wide view while lying down and staring into the mirror.

It was thus that the Boy and the Vendor arrived at their arrangement. The Boy got him things, in return he made sure that the Boy never got the same sandwich twice, and gave him a good deal on the things he brought.

One day, when the Boy had just had his sandwich, arriving from god knows where duly at noon, and had left, this time carrying the sandwich, rather than eating it there, an odd-looking man walked up to the Vendor, and mumbled something. The Vendor looked at him, and looked away because there was something strange and intense about the man. He did not reply. The man said then, thinking the Vendor a little slow to understand, in a sort of whisper but not an undertone,

"I have something that you could sell and make a huge profit."

"I am not here for a huge profit."

The man stared at the Vendor in an odd, crow-like manner, tilting his neck, like a referee in a match weighing an appeal. He was dressed better than he looked, in expensive clothes that had a polymer technology shine on them, but rather typical, like jeans and checks. The Vendor, his curiosity aroused a little, was beginning to feel uncomfortable under that stare. The man said, suddenly effusive and suave,

"Oh, well, but see, I am planning to open a shop here, in that broke-down café place, but I want to see if there is a market for my goods here, and I want to see if somebody buys them from you. This is my personal, secret, pilot campaign."

"You work for a company?"

"Uh, oh, yes, well, yes, of course. In fact, I am Chief Market Analyst for a rather big, multinational company!"

"What do you want to sell?"

"Oh yes, of course. No, I don't want to sell anything. I want you to sell something for me."

"What is it?"

"Oh, uh, you see, this is a really secret product, so we must be careful. I can tell you, and show you what it is only if you agree to selling it."

The Vendor was curious. He had also begun to wonder if this was something for the Inspector, Crime Branch to be interested in. So he said,

"Yes. Okay. Show."

The man started positively beaming, and put his briefcase on his knee, finely and athletically balanced on one leg, he opened it, and extracted a spray can that looked like a small can of perfume or deodorant. Looking at the man, balanced on one foot like that, the Vendor began to be sure that there was something of a deception in this man. How many Chief Market Analysts of multinational companies can open briefcases, balancing them on the other knee, and themselves on just one leg? How many of them do not have potbellies and sweating armpits the moment they get out of their offices or cars? And have biceps that bulge and un-bulge like balloons when their arms move? The Vendor was terribly impressed and deeply frightened by the man's athletic performance. He took the can, and in a nonchalant manner, put it beside the Shaeffers pens. Then he asked the man,

"So what is it, and how much does it cost?"

"It's a new perfume that we have devised for the local market. Please understand that this is still a secret product. We are planting it in various shops and vendors, without labels, to see if people go for the perfume, or for our brand-value. We are a known company, see?"

"You must be Revlon, then."

The man laughed out lout and said,

"Oh well, no, we are bigger actually, yes."

"I see. So what's the name of the perfume?"

"It's called White Magic, you know."

Seeing that the Vendor had not understood, the man explained,

"It's a joke, see, on black magic. White magic is something that you don't notice, you know. Like white noise?"

The Vendor could not bring himself to smile, and said,

"How much should I pay you for this?"

"No, no, you don't pay me anything right now, take it on deposit, I will. But if you sell it, you let me know. That's the deal. I will come around again in a few days. See you then. Happy Vending."

With this the man walked away towards a waiting car the Vendor had not noticed. He had seen the car earlier somewhere, but could not remember where. As the car drove away, he thought this incident was not worth the notice of the Inspector, Crime Branch. After all, it could very well be as the man said it was. But the can of perfume unsettled him with its pristine white.

The next day, as the Boy wheeled towards the Vendor for his sandwich, the white can drew his attention, and as he picked up his sandwich, he asked the Vendor,

"Hey, what is that?"

"White Magic," he said, "Some kind of perfume."

"Can I try it?"

The Vendor considered this unusual request, but nodded. The Boy picked it up and sprayed a little perfume on his cuff and smelled it.

"Yeah, it's good." He said.

"Keep your eyes open for it," said the Vendor, "in other shops and other Vendors."

"Alright, if you say so."

Two days later, the Boy said,

"Hey, it actually is there with other Vendors on the other streets. I almost bought one."

"Really?"

"Yes, yes."

But the Vendor was uncomfortable still. He just did not understand why a real Chief Marketing Analyst would personally come and try what the man had. After waiting for two days, spending a few hours thinking about it, he called on the Inspector, Crime Branch.

Who was intrigued by the reported event. He said,

"Oh well. Listen. I think this is a little suspect, so you keep your eyes open. This is what you should do. If the man comes around again, make sure you get his car number, or his card, and look at him carefully, so that later you can identify him if necessary. The description you are giving right now is not enough for anything. And don't worry, it probably is not dangerous at all. Be careful nevertheless. And of course, you will tell the man you want more of these, because they are selling, right? Keep away the one he gave you."

"But, don't you want it—"

"For fingerprints? Come on, all that will show are your prints, and that Boy's. We will have to get yours and his for elimination. What I am suggesting is simpler."

So the Vendor went back, and waited anxiously for the man to return. Having committed himself, he was now worried that it may come to nothing. But for two days, apart from stray buyers, and the Bicycle Boy, nobody turned up. He told the Boy everything he had done, and told him to be on the look-out for the car once he got the number. The Boy, in any case, would be a far better look-out than the police.

On the third day, the man turned up, getting out of the car at a distance. This was curious in itself, the Vendor realized. He was getting worked up. He couldn't see the number plate clearly because he was anxious, his blood was pounding through his body, especially his eyes, as he stared hard. The man came nearer and smiled an unexpectedly toothy smile, all jovial and comrade-like.

"Oh, hi, hello and all that."

"Hi," the Vendor said.

"So did you manage to sell the perfume at all? Ah ha, well, I can see that you have."

"Yes, and the kid who bought it said he wants more."

"Ah ha, that's nice. Oh well, in that case, you see, you will have to fill up these forms I have, since now we can make it official, like?"

Now the Vendor was a constitutional hater of forms. When he had gone broke, he had almost pulped his fingers, filling forms and signing in ten thousand places.

"I hate forms," he said.

"Oh really. I see. So do I. Maybe we can make a small concession."

This time the man put his briefcase on the cart, and opened it to reveal cans of White Magic, neatly laid out in a row, secured with Velcro straps. The briefcase itself was expensive.

"So how many do you want?" the man was saying.

"Three."

"So here you are, one, two, three," punctuating his counting with the tap of each can on the counter.

The Vendor, all this while worrying about having to touch the cans, was much relieved. He had been trying to find a way of not touching them as they were handed over. The man had solved his problem. Now they could be given over for lifting the fingerprints.

"So how much should I give you?"

"Oh well, how much did you sell the last one for?"

"Five."

"Ah yes. Give me fifteen then."

The Vendor opened his cash box and handed over the money. The man walked away, putting the money carefully in his wallet, got into the car, and drove away. Just as it turned round the corner, the Vendor, wonderstruck, saw the Bicycle Boy emerge from the other side, and follow the car.

The Boy returned after an hour or so, and gave him the number, and said that the car was a four-year-old Ford model, expensive at that time, and that the car went away without stopping at any other shop, or Vendor. As he reported, he stretched his hand out to the cans, still half sitting on his cycle, and the Vendor yelled,

"Don't touch that!"

"Why?"

"I am giving them to the police for fingerprinting."

"So how are you going to carry them, then? You've to touch them to carry them!"

This was a puzzle that had to be solved. He had seen enough films to know that fingerprinting is best done *in situ*. But he could not

get the police here immediately. He had to carry them... This was going to be a very delicate operation. The cans were still sitting there, ominous in their white.

"Alright, Boy, let's do it. Our first lesson in forensics. Now what we have to do is reconstruct how the man put the cans, how he was holding them."

The Vendor came away from his cart, and stood where the man had stood, and pretended to hold the cans and put them down.

"So now we know the most likely places where his prints will be found, right?" Now what we need are forceps, really, which in our case we haven't got. But let us see what we can find."

The Vendor rummaged in the boxes under the cart top, and finally emerged triumphant with a pair of kitchen tongs, old, really old.

"Alright, implements for Phase One now available. Let's see what we need for Phase Two: Transportation. We need something to put the cans in, and make sure the prints are not smudged."

He rummaged again, and emerged this time, beaming, with a box filled with thermocol pellets in it.

"Alright, we are set, then. We need to make sure that these little thingies don't smudge the prints. So what we do is we empty about half the box, like this, you will notice the man's prints are nearer to the top, so half should be sufficient, and necessary, to stop the cans from toppling, we don't want that, do we?"

The Boy was staring at him, the box, the cans, slightly bewildered. The Vendor touched the top of the can, tilted it, slipped the tongs underneath, and balancing the can between finger tip and tong, placed it in the box. The pellets adjusted themselves around its weight. He put the other two cans and shut the box tight.

"Voila," he said, "we're done."

He gave the Boy another sandwich, and ate one himself. Then he shut down his shop, by the time the Boy had munched through the sandwich, always a reluctant eater like his daughter, he was finished and was ready to leave.

"I will now take these to the Inspector." He said, gravely.

The Boy nodded seriously, picked up his cycle and left, speeding very quickly. The Vendor slowly trudged his delicate way, holding the box steady, to the Inspector, who said,

"That is really good, old fellow. Let me get the forensics woman and lift the prints. I am sure you want to find out more, so why don't you just help yourself to a coffee, here, while we lift the prints and feed them to the machines and see what they throw up? I am sorry I can't give you anything to read but the Stock News. You want it?"

The expression of extreme disgust that the Inspector saw made him realize what he had just said.

"Oh yes. Of course. Sorry I asked."

The prints and the match were ready in an hour's time, and the Inspector said,

"This is fantastic. The man's a known criminal, used to work for a drug dealer. So now we are seeing what's inside the cans. That will take time, I suggest you leave now, but give me a call tomorrow morning, if you like. Here's my card. And yes, thanks for the car number too."

The Vendor was a little bored now, he was thinking of leaving anyway. He could not understand why a criminal who used to work for a drug dealer would want him to sell White Magic.

The next day, he took the first can of White Magic with him, and put it on the cart for everybody to see, and to make sure that everybody saw, he made a sign which said, 'White Magic Available Here!'" and rested it against the can.

The Bicycle Boy turned up and asked him what had happened. The Vendor reported to him all that had, and then the Boy said,

"I know what they're trying."

"What? What are they trying?"

"They're trying to muscle in their way to a Coca-Cola dealership."

"But what's the connection?"

"Last evening, as I was going back home, I saw the car again, and it was following the Coca-Cola VP's Mercedes."

"How do you know?"

"Come on, the VP lives next door, I have seen the car all my life!"

"But this can?"

"That I cannot know."

The Boy left soon after. Around afternoon, the Vendor saw a Merc drive down the street, slow down a little, and a man peered at him from the rolled-down window. A suit and tie man. As he stared at

the man, the car sped up and left. The Vendor was getting intrigued. In ten minutes, the White Magic man's car stopped near him, and the man came along.

"So, ah, well, I notice you sold two more."

"Yesss."

Then he asked,

"Tell me, what's the point of this all? I am not stupid, you know?"

The man fumbled for a second, and then smiled his toothy smile and said,

"Come on, old man. I told you already. This is an experiment in new marketing styles."

Just as the man finished the sentence, the Vendor heard thudding boots, and before he realized what was up, he saw the man running away, and two policepersons saying in unison,

"Stop, or I will shoot!"

The man did not stop, the policepersons did not shoot, but ran after him. The man was already inside the car, the car was revving up, just as one of the policepersons reached close enough to put his hand through the window and get a hold on to the man. But all he caught was the man's shirt, which ripped as the car picked up speed, and the policeperson fell down. The other one started shooting. The window shattered, but the car got away. The other one was already speaking into the radio, and the Vendor was already breathing less heavily. He was sure that the car would be caught, and people arrested.

Two days later, the Inspector, Crime Branch came and thanked him. The Vendor was a little angry with the Inspector because he had not warned that there would be a stake-out. The Inspector apologized, but he was smiling. The Vendor said,

"So what was that all about?"

"Oh, don't worry about all that, now. It's all taken care of."

So the Vendor never got to know the point of all that White Magic business. When the Bicycle Boy came around the next day, he, however, had a story to tell, and he was glowing with as much pleasure as the Inspector.

"Know what? I finally avenged myself. Remember I told you about this Grey Suit, the Coca-Cola VP, his Merc and all? Well, you know, last monsoon, just as I was turning the corner near my house,

the Merc came, and turned rather sharply, and there was a largish puddle there, and the fucker splashed all that muddy water on me as he turned. So I was like very angry. Last evening, well, almost night, dark it was already, as I started thinking of getting back for dinner, I saw the Merc parked, its door open, near that five-star hotel, you know, six signals away? The car was empty. So I went a little further, and turned back, thinking, if that VP comes around I am going to ram into him or something like that. You know I carry this tool box, for my bike? Well, it also has a can of grease, for the pedal and the ball bearings, you know? So know what I did?"

The Boy laughed hard, lost in his own story. The Vendor had to bring him back to the telling.

"So I took out the can, opened it, and held it in my hand, and waited. Then I saw this VP come out from the hotel, AND, he was with a gorgeously dressed woman, dressed all sexy like, in a red dress, I mean like, tight, like SQ Sajnovics, you know? So as he approached the car, I speeded up, and just he was turning around the door, banged into the car. It is important not to bang into him, right? This has to be done carefully and cleverly, now. The can must be held in such a way that it does not splash grease all over you, or your bike, but only on the target. Which means speed and angle of impact must be carefully calculated. I did that."

The Vendor was not able to figure it out. He said,

"So?"

"So? You didn't get it? Oh, I banged into the car, just as he was getting in, after holding the door open for the woman, oh, I saw quite a bit of nice leg there, almost braked automatically. Sooo, here he is, holding that door open, slightly bent, with his bum sticking out a little as he is bending, see? And saying something to the woman."

The Boy was enacting the scene, having made that universal gesture which said,

"Watch me!"

"So I bang into the rear of his car, and the grease can, well, it goes flying from the impact, and splashes all over him, man."

❅

The Bridge Man

The Bridge Man lived in a world entirely his own, and he was very happy with it. He owned his world entirely, and he had made it exactly as he liked it. It was a world into which only those who knew the basics of electricity entered and in 2050, only schoolchildren knew the basics. Schoolchildren did not enter the Bridge Man's world because they were never allowed to walk on the bridge, and they did not do that because only cars passed over the bridge, and the schoolchildren were not yet permitted to drive real cars, not even the automated ones. It was necessary to know the basics of electricity because the Bridge Man spent a lot of his time crossing high-tension lines (BEWARE: 44,000 VOLTS!). The bridge carried these into the other half of the City. The high tension lines more or less covered the bridge, its sides, went high over the bridge, and along its underbelly where the Bridge Man slept at night; they were everywhere. The Bridge Man was never bothered by them because he remembered his school-level electricity, though he remembered very little else of his life.

He slept under the bridge, on the girders which carried the electrical lines, between the lines. The bridge itself was about twenty metres high, over the only river into which the City poured its waste. The river bed witnessed water only once a year, when, during the monsoon, the City decided that the dam across the river was too full, and opened its gates, letting out hundreds of cubic metres of green and blue water.

This was the only time that the Bridge Man experienced water too. This was a glorious annual moment, one that he rarely remembered for longer than the monsoon lasted. Over the years, he had developed a sixth sense about the opening of the dam gates. He almost smelled the dam ripening across all that distance, and normally saw the oil and tar and polymer that the river bed usually carried being pushed at a faster rate when the gates were opened.

When he saw that movement, that push, he descended from the bridge, using the precarious staircase that the City had left undemolished for reasons never known. As he came down the spiral, he saw snapshots of the water coming along—as he turned, he saw the immense pillars, the City's waste, the distant City-scape, as he turned again, he saw the glorious water coming along nicely and ruthlessly, like a clean destiny. By the time he reached the river bed itself, the water was flowing nicely, pushing all the polymer and rainbow effluents away. The Bridge Man always made sure that he had a piece of plastic with which to wipe away the layer of grime on his own skin. He always wiped his body before getting into the gush of the water. He never allowed his own grime to enter into that clean blue-green-white shiny frothy water. He stripped, and entered the water carefully, a minute or two after the water settled into a consistent and steady flow. He bent his head first, to smell the vegetables which the water had fed, the cauliflower, the papaya, the various gourds which the food factories grew and processed around the dam. The Bridge Man was particular about his ecological morals, but sometimes he was tempted to be sinful, and pissed in the flowing water. When he did that, it invariably reminded him of whatever little bit of his past that he remembered, his hacking days. Pissing in that flow of water was like hacking, he introduced his own flow of information and commands (the urine contained acids, his body-commands) into that immense flow of information. When he was reminded of those days from his dimly remembered past, his fingers twitched and he involuntarily typed out whole sequences which tested the N-value TCP layers and the ICMP6 and the old TTLs of the world, treating that immense flow of water as his personal keyboard, listening on all the ports, listening for other systems, for the ports on which they were listening, groping for an open port through which he sent his own instructions, caused a kernel overflow, and blissfully, almost sexually, entered some other system.

But the feel of water on his body was much more enjoyable, and he soon entered the water up to his throat, his waist-long hair—matted and knitted by arbitrariness and randomness in such a way as to form a permanent shawl on his back—floating, unmatting, unweaving, turning from the yellowish-brown that it was for the major

part of the year, to grey. For a few minutes, the grime released from his hair formed a swirling pattern on the water, and then it was gone. The Bridge Man did not need shampoo.

By the time he emerged from the water, his hard leathery body was bronze and brown, his eyes shining like a primitive god emerging from the water for the first time, looking at his own world, and his tread was that of a conqueror. He climbed back onto the staircase, and sat on a step, his feet in water. This was the only sentimental moment that he allowed himself, and he remembered his past life.

The Bridge Man had once been a Railway Man. He had been many things in his life, and gathered the oddest pieces of knowledge with which he hacked into the world of others, sometimes disrupting other systems, sometimes making sure that his presence was never felt, leaving no time-stamps of his passage, no traces to be traced back to his system. His system was now complete in itself, he had unplugged it from the rest of the world. He himself, his own system, was unhackable. When the Bridge Man was a Railway Man, he had learnt from another major Railway Man how to hack into electrical lines, make an electrical stove to roast dead animals, so that there was abundant food, always. He had eaten monkeys which managed to escape the zoo and ended up in railway tunnels, rats which were always available. But there was better and enough food usually, because the City always threw away a lot of food from the trains. All you did was to roast or to fry or to heat up everything properly on the electric stove. One Railway Woman had taught him how to make a blender from bit parts of broken down machines, but for those parts, she negotiated with the Junkyard Couple—two men who were always kissing each other, but who always, within minutes, came up with whatever you wanted. They never eyed, nor made passes at other men. They were deeply in love with each other and what they were. They seemed to be able to live happily in a world of their own.

When he saw the Junkyard Couple for the first time, he felt curious enough to consider becoming a Junkyard Man. He even mumbled something about it to the Junkyard Couple, but they had only stared at him uncomprehendingly. In any case, he liked living with the Railway Woman. She had a great mind, he thought. He respected it enough not to hack into her mind.

The Bridge Man, much, much before he became a Railway Man, had been a Hack Man. Other Hack Men around him always called him Gene Hack Man, because he was too old and too angry and too moral to chase them across the streets of virtual New York or virtual Paris, and because he pretended to have a short temper. The Hack Men were really very respected by the City. It always paid the Hack Men well enough to buy the most expensive mid-range cars, it paid their premiums, it gave them interest-free loans to buy expensive miniature apartments where they lived happily with their single wives and children. But Gene Hack Man never married, and never had a child. He never fell for a woman hacker. His only woman of desire was SQ Sajnovics, Scream Queen Sajnovics, who was invariably raped in sequential films by every creature known to the collective imagination of script-writers, from man-sized bats to room-sized robots, but who always managed to live happily ever after the film ended. Every hour he downloaded a picture of hers, and every day a new film. He had automated the downloads himself. She was a prolific actress, estranged from her Mittel-Europe culture, and hungry for success in World Cinema, which meant Hollywood. Gene Hack Man was perhaps the only one who remembered her after the film was over. He lived happily with her, in his imagination.

Gene Hack Man, in the days before he became a Railway Man, was no Data Miner, or Knowledge Manager, no roadside Security Programmer. He was Chip Designer. When other Hack Men were in the mood, they asked him to design porn chips that they added on to their systems, and wrote codes that generated random 3D porn. For Gene Hack Man, who had had enough of sex by then, it was kid stuff. He was onto bigger things, he was trying to hack into the world itself.

He began by hacking into support systems. He never paid his monthly installments on his loans after that. Then he stopped paying his credit card bills. Soon he moved on to doing that for other Hack Men. When he found out that he could hack into any system, he became ambitious, and that made him careless. He left a time-stamp unchanged, once, having hacked into the City Central System, looking to buy another apartment without paying for it. The City never allowed anybody not to pay for living space. He knew that, though, and the day before the Digital Crime Police came for him, he left everything, taking only his radio-modem, his wearable system, and he

decamped. He did not even take the old plasma copies of Modigliani nudes that he was very fond of, which he actually paid for, and hung on the ceiling of his bedroom.

He decided that he had had enough of being a City Man, and decided to become a Park Man, and shifted to a remote park in the City. Three days into being a Park Man, late in the night, as he hid behind a tree and logged into the City, a Drug Man cleaned him up. He did not hear the Drug Man come up but only saw the large knife as it deftly rested on his throat, and saw his wearable taken away.

For a few hours, he lay half conscious, his fingers tapping away at the no-longer-there keyboard. Then he fell asleep. A dawn jogger threw previous night's food at him, and he woke at the slap of a soggy pizza plastic packet on his belly. He ate the pizza, and felt happy and relieved. He had survived his first night without a system, first night in twenty-five years. He took out his already dirty handkerchief, tore it into two, and tied his fingers together, so that they did not unconsciously tap away at no-longer-there keyboards. He was then forty years old.

Two years into being a Park Man, he knew how to steal food from unsuspecting joggers who always carried food so that they could later jog more to burn away those calories, he knew how to make a large knife from metal pieces, he knew, above all, kung-fu. He studied for a long time with the sensei, who made his living by teaching Park Men how to fight. All the Park Men knew each other, and allowed each other to move into other parks. The Park Men had their own code of behaviour which he quickly decoded and learned and used, and improved. He in turn taught several others how to decode credit card magnetic strips and use them to get cash. The Stealers got him credit cards, and he put them in a reader that he made from parts stolen from ATM booths, and handed them the personal key information.

Four years into being a Park Man, he decided to become a Climber, because in a magazine that a handsome skinnily muscular youth had left on a bench, he read about Reinhold Messner, a Climber. But there were no mountains nearby, so he decided to become a Tree Climber, and introduced a new way of being to the Park Men, a new form of life, a new language. He followed Messner's training schedule to the letter—practise climbing for three hours using only three fingers on each hand—hang from branches from one hand for one hour.

Use only the tiniest hold you found and put your toe into it and push, push, push yourself upward, from that tiny hold onto another branch; if faced with an overhang, haul yourself up with legs first, and above all, do not be afraid of heights, or looking down from heights. If you are strong, you do not fall. The first time he reached the top of a tree without slipping once, and always knowing what to do next, he began to love heights. He also learnt to climb trees silently, steal up to nests that birds always made there, steal eggs, sometimes catch whole birds and roast and eat them. He remained a Climber for a very long time, and he was greatly respected by the Park Men.

By the time he was fifty, he had forgotten most of his earlier life. He did everything that there was to be done as a Park Man. He helped keep the park clean of dead Park Men, who were surreptitiously shifted out of the park, he took part in protests to preserve their right to live and die as they wanted to, he prevented social activists from entering the park to improve their own moral self-esteem, he fought with the police, was in prison for six months for being a Park Man. Eventually, the City decided that it did not mind the Park Men and the Junkyard Couple and all such people because it did not have the time and money to improve their lot. Social activists found them ungrateful, and abandoned them after a year or two of attempting to teach them to read and write and wash themselves. He did not let on that he knew more than the social activists, who were usually either pretty college kids, girls and boys, or wizened politicians who were after everything else but what they claimed.

It was in his fifty-fifth year that they started to construct the New Bridge Across the River. The City people always proudly called it the N-BAR. They came in cars to see how it was constructed, and the engineers congratulated each other at every stage of its construction. The N-BAR was completed in a short time of three years, and each day, he watched the construction from a tree-top in the park. He got a young Park Man to grind glass to make lenses, and fitted them in a retractable tube to make a monocular. He watched how they mixed the cement, how the engineers keenly calculated heights and stress and strain, and how the electricity people finally laid the lines all over the N-BAR, above, under, on the sides. When it was complete, it became quite a tourist attraction.

In a year after the N-BAR was completed, he got tired of being a Park Man, because now people from the other side too came to jog and entertain their dogs and children with frisbees. There hardly seemed to be a place where he managed to sit by himself during daytime. As more people came, the Park Men were noticed more, and eventually the City got serious about the Problem of the People Who Live in the Park and Scare Children.

He stopped being a Park Man, he set out with his bundle towards the outskirts. Now he did not know really what to become. He wondered if he should think of dying, but he did not see an interesting way to die. While thinking about death he came to the train station, and realized that he had been a Railway Man once. He went into the train station, properly paying for his ticket, and making sure no one was there to watch him, sitting out the while on a bench, late into the night, he walked into the tunnel, and became a Railway Man. He rather liked the image of himself as he imagined some secret observer, or a video camera watching him as he walked in with his bundle dangling in his hands, like SQ Sajnovics walking into the sunset in an uncharacteristically tragic film.

But by the time he became the Bridge Man he had lost even that interest in himself, or in anything else. He was hacking into the backbone of the world itself, and he did not want to be distracted, by himself or by others. When he came onto the N-BAR, he decided that it was only a bridge, and started calling it the Bridge. For the first year, he tried living on the Bridge itself, on the footpath which was meant mainly for maintenance engineers and the first-generation maintenance robots. He always confused the badly designed robots by blocking their path but going away before any human realized that the robots were not moving. He devised a very simple technology to disappear from the Bridge at short notice. He hacked into the architecture of the Bridge itself. He tied a rope to one of the railings, and if he did not want to be seen, he quickly descended down the rope, and hid under the bridge, and he tied the rope with a sailor's knot, to be pulled, merely, to bring the rope down. Only once he startled a maintenance man by emerging from underneath, right beside him. The man was scared to death, and the Bridge Man saw the blood

drain from his face through the glass on the man's helmet. It was then that they realized that he was living on the N-BAR which is what they still called it.

In the second year on the Bridge, they decided that it was too dangerous for him to live on there. They came with an ambulance and a police van, but without the maintenance engineers who knew their basic electricity. When they came closer, he climbed onto a high-tension line, and dangled from it. No-one dared touch him as he dangled from "BEWARE: 44,000 VOLTS!" He decided to entertain them, and slowly began to swing, and then jumped, like an acrobat, on to another line. The policepersons gasped in fear as he gripped the second line. But he knew he could do it, and did it. He had lost none of the litheness that he had acquired from the sensei in the Park. He had always loved the lines, they always hummed him to sleep under the Bridge, and he knew that they did not mean any harm to him. After an hour, the ambulance, and the police, left.

After that, whenever they decided that it was too dangerous for him to live on there, came to get him, he entertained them by dangling from the lines, jumping on them, swinging like a trapeze artist. For some time, he became a tourist attraction and made money, as people who stopped their cars threw him coins if he was practising his trapeze skills. Whenever the coins landed on the lines, they sizzled, and only a melted metal drop fell down. After seeing that, he kept tins at regular distances, and put up a sign, "If You Like Throwing Money, Throw It in the Tins. Food Is Preferable, However. Thank You."

But after that, he took to disappearing under the bridge at night to sleep. Because it was much more quiet there, only the rustle of the crow colony, beside which he found a large enough gap between the lines under the bridge, to lay down his blanket and to sleep unmoving, and snoring. The crows were very disturbed, and once tried to attack him. He merely shifted to the egret colony three pillars away. The egrets were milder birds, it seemed, and were not too mindful of him.

In the second year, he faced lack of food because now the people who came to watch him got bored with him, and did not give him food. The City was in an economic recession, and very few people threw money into the tins. Then he came down with all his money to

the end of the Bridge, and from a super-store, he bought fifty cans of assorted tinned food. The cashier, a girl, stared at him wildly with her ultra-violet blue eyes, and produced a dazzling smile. He fondly thought that what she saw was an old but strong-looking man with a long shawl of hair on his back, a face that was more passive than her father's, and eyes that were rheumy, but shining with pleasure. She passed him a can of beer. He put his hand in his pocket after paying, and slipped a coin in her breast pocket, and came out with those fifty cans of food and a can of beer on his back.

When he finished a can, he put it at the end of the Bridge. It took him more than a year to finish all the cans, which he collected in a row. This experience of collecting and preserving them put him in the mood of collecting. For the next two years, he collected every part that came off from cars that passed on the bridge, and sometimes, when there was an accident, he was invariably the first to reach there, and knowing that he did not want to do anything for the humans, he collected whatever he needed. One car was not very badly damaged, and he took out the cushioning, put it under the man thrown out of the car, and took away the rest of the cushioning to make a comfortable bed. The police, the insurance men and watchers were always too busy with success rates to worry about missing parts of bust cars, and thus, over the years, he managed to make quite a lived-in nest under the bridge.

The Bridge Man lived on the bridge for fifteen years. They introduced automated cars, and his main source of food diminished. Only schoolchildren now found him amusing, and still threw some food for him, from their lunch boxes. The Central School Bus always produced more interesting food than the cars, the bus gave him more variety in taste, and a better class of food. He took to coming near the spot where the bus normally slowed down, and over time, he began to recognize the children, see them grow from little toddlers to proper schoolchildren. When they grew tall, they stopped travelling in the bus, moved on to higher education. The children stared at him through the windows as he stared at them through the metal grid that kept him away from the road. The new kids always screamed with joy on seeing him, or at least he thought so, and older ones, more familiar, and more business-like, threw him packets of food which, most likely,

their mothers had made. He was always pleased with the children, because to connect with them, he did not have to hack into the world. Only once did he feel like speaking to a very nice little girl, but when he tried to say hello kid, he found that no sound emerged, and he realized that he had not spoken to anyone for a very long time indeed.

In his sixteenth year on the bridge, he saw twenty-nine accidents with ten fatalities, twenty-seven broken hips, and twenty-three minor fractures, he saw thirteen automated cars break down or go out of control, causing two fatalities, seven serious injuries.

One day he saw an automated car go out of control, crash into the Central School Bus, and explode. As he saw severed limbs of already dead children falling down, he decided that it was the last day of his life. He climbed over the grid, and collected all the unconscious but alive children and arranged them in a neat row. He did it quickly, because within half an hour, the rescue squads arrived from the City. Then he descended to his bed and carefully pushed it into the already murky river below, and climbed back onto the bridge. He faintly heard the sirens of the police and the ambulance. He jumped and hung from a high tension line, and waited for them to arrive. They understood what he had done and were puzzled. He had never done this before. One policeman came close to where he dangled, and stared up at him. The Bridge Man made the universal gesture, with his two fingers sticking out first, and then pointing at his eyes, "Watch me!" and then, very slowly, and very gently, he reached out with his feet, and touched another line, bridged the gap between the two.

With a flash, the electricity burnt him, reducing him to a black, scorched disfigured body, stretched out on all three long limbs, one leg jerking in mid-air, like a scarecrow, or like a monkey in a lab, convulsing as the electricity moved through him.

Parts of the City lost electricity. The fridges, the TVs, the computers, the telecommunications all went down, the lifts stopped. Less than a nanosecond passed, until all the genset backups and trip metres and support systems kicked in and order was restored, without anybody noticing that the electricity had failed.

❄

The PI Speech and Coda

"The PI is not a Private Investigator, it is actually a Software Suite, though everybody knows it as the Inspector. The more particular people naturally call it PI Software Suite, take care not to use the obvious acronym in workplaces or in polite company.

The PI is also an AI, meaning software that uses neural networks, and comes closest to artificial intelligence. Nobody really knows how to make intelligence artificial, so nowadays, of course, everything that learns something on its own, and has N-layer neural networks—in the chip itself, or in the code depending on how much you want to pay for AI—is called an AI, or a Spielberg.

Since you don't know yet, you wonder what the PI does. The PI is not merely a software suite, you find out, but it is also a machine. Well, you think, naturally, since the software suite must have some hardware body. I mean it is so natural for a software suite to have a hardware body that you never wonder whether they could ever be separate, right? So now this unity of hardware and software does some very special things, because it is an Inspector. And you will be right in thinking that in 2050 Inspectors get to do a lot of special things. And in case the hardware is not up to the task, the software kicks in all the connections to the net, and slowly spreads its pseudopoda though the network, querying, pushing, pulling at bits of information, eventually and without fail coming up with what it wanted in its jaws.

When I wrote the inner core of the code, I called it the Particulate Inspector, because you see, the earlier hackers, they were being silly in the way they treated information. These primitive hackers had only two basic conceptions of information—it was either a series of zeroes or ones, or it was words, or images (still, or moving) or sounds, and these non-binary pieces of information were indivisible atoms. So in my 14th year, I was like, come on guys, and yes, come on Ye Gorgeous Hacking Gals too, you are, like, being silly, you have

forgotten physics that is what, a hundred and fifty years old? You will naturally think now that I am going to go on boasting about myself, and go on bashing the earlier generation. You are right.

So I told them about how in the hoary past, some guys had suddenly realized that the atom was not an indivisible unit, and so on. But of course the more interesting observation was that the atom was made up of particles. So here I am, talking to these hackers in this shack with maybe a thousand, like, hooking all of us to each other and to the rest of the world, and telling them that they are really mere nerds, not hackers at all. We must break down units of information, which are made of particles of information.

Well, there was a generation of hackers there which was younger than me, and another generation which was like about to retire from burn-out after making money, at twenty-five. And as you have rightly guessed, it was the younger generation which even heard what I was saying, I mean hackers in their twenties are confident of what they know, so why would they listen to kids, capisce? But the younger ones were not of an age that allowed them to understand what I was saying so they merely looked at me with curiosity, and went back to their own chat groups, and found childish ways of childishly breaking into so-called secure government web-sites and defaced them with anti-government slogans, or told the pigs that they were pigs. Childish, as I said.

As for me, I went full blooded into research on particles, and knew most of them personally after a month of feeds from the net, chat groups and webpaedias. Hey, listen, you are listening to a hacker who knows particles and talks to them, okay? I mean, look here, LISTEN with some RESPECT, okay? Don't make me yell, please.

So I went about my business, researching particles for almost a year—hell, the university would happily have given me a PhD for that research, you know, but I wanted it for myself, I wanted to do it all by myself, for myself. That is, after all, what a hacker wants. After this period of research, I was talking particles, seeing particles, and yes, listening even to older particles like Bosons and Mu-ons. There were nifty folks in there, inside the atom, one wasn't always sure that they were there. Sometimes they move about faster than light, too. But after that the physics and the maths became a little confusing,

and I decided that I knew enough for my purposes, and set about writing the core of the PI.

I started with the idea of a Gleaner—you know, that thing that you have on your desktop, it traverses the net and gets what you want without you having to do anything except define preferences and configurations once in a while. I wanted my Gleaner also to be an Analyser. There still aren't very many good analysers, as you well know, in spite of some pioneering research done by Hawke some decades back, who probably had a glimpse of what needed to be done, but alas, did not have the patience to do all the maths, and ended up a discredited maverick.

So I set about writing a Gleaner—some people still call it a Google—out of an automatic academic historicism—which was also an Analyser. Naturally I called it a Gleanalyser. I stuck to that name for a long time, but after a while, the code itself changed, its aims and its functions changed, so I gave it up.

Anyway, since I am boasting, I might as well tell you how I went about it, my friends. But you must be patient with me, dear ones, as you always are when listening to a story. And well, I don't need to remind you, but I will anyway, that you already know quite a few things about computation, things like how hackers treat the chip like a Black Box (they don't, and don't want, to know what happens in there, in that beautiful beautiful beautiful place), how most code is still written in versions of C, sharpened or flattened, rounded or squared, if you know what I mean, and how C is OOL and all that kind of basic stuff.

So my first breakthrough was in realizing that a mere Object Oriented Language was not enough for my purposes. So I tweaked the latest version of C—it was then called C'YA—C, Yanked and Advanced, taking it a few levels under, making it more granular, like. I mean what we have here is like Einstein versus Quantum Mechanics, okay? So I wrote a version of C'YA all over again, and called it—well, you know the name, but I must tell the story properly—CQMe—C, Quantum Mechanized, like. What did that mean? That meant that instead of treating Objects as Objects, we treat them like a collection of particles, which is what they are anyway, right? Hey, listen, don't confuse particles and molecules, okay? Your standard particle is a very small

and very fast and very unpredictable fellow, I mean it's like an ant, whereas your standard molecule is a huge, heavy fellow, like an elephant or something. Well, you know that, actually. Am I blabbering? Am I boring you? No? Good.

So once I decided that an OOL could be broken down further to consider particles of information, I then had, yebboy, a field theory of information, where a particular constellation of particles of information made up your 0 or your 1. See, this is a clever thing to do, because alas, all machines are still merely binary, and so what I had to do was to allow for that binarity of machines and still get down to that valuable level of a field theory of informative objects. So now sub-routines in the code could be broken further down, and the values of 0 and or 1 themselves could be broken down, because I stipulated that if and only if certain informational conditions are met, the 0 does not become a 0, and the 1 does not become a 1. The beauty of all this, of course, is that all this is done using binaries anyway. Let me, at this point, seek to illustrate.

Take a statement like "The cat is on the mat." If there is no cat sitting, sleeping, lying down, (or any other actions that cats can/might perform on mats—hackers must take into account all the possibilties, because the sentence only says "is") on the mat, then the sentence is false, the gate is open, current does not pass, the programme knows this is 0, it returns "false". This is neatly represented by X is Y. But my friends you will realize that "cat" here could very well be replaced by "dog", and make no difference to the programme. Hey Ludwig, your connection is slow, man, are you listening? Uh oh, sorry for that aside, friends, but Ludwig is an old friend, though very young still, and I do want him to hear this out from his remote hut in the Swiss mountains. He built it himself, you know, with his own hands. Anyway, as I was trying to point out, all the hackers have been treating objects and the activity of coding itself as a purely formal thing, they are being deeply Platonist, you know. Thank god, I managed to put a brake to that.

So as I was saying, what we needed was a coding system that will allow its formality to be infected with some real content, like, and this is what I managed to do. The way I arrived at this is curious to me now, and that process itself shows the necessity—performatively—

of what I am trying to say. Like many other hackers, I am addicted to SQ Sajnovics movies. You know her, Scream Queen Sajnovics, who was invariably raped in sequential films by every creature known to the collective imagination of script-writers, from man-sized bats to room-sized robots, but who always managed to live happily ever after the film ended. So there was SQS, under attack by her lover (who turns out to be a malfunctioning oversized human being for a change, not an alien creature, nor a robot), and I am looking at her face screaming, and I am trying at the same time to tap out a bit of code in the other window, and I realize that I cannot get that scream into my code, though it is screaming, so to say, to be coded. So I stop tapping that bit of code, which was only for bells and whistles on the main stuff anyway, and freeze the frame, and stare at her face, thinking hard.

Let us define a scream. This is a Perl of Wisdom.

```
;SCREAM
//breaks down into
;FEELING OF FEAR
;[AND]
;EXPULSION OF HIGH PRESSURE AIR THROUGH VOCAL CORDS
;FEELING OF FEAR
//breaks down into, surprisingly, a higher level category of
;FEELING/s
//use auto-didactic neural networks//
;[AND]
;SENSE OF DANGER
//breaks down into
;NECESSITY OF SURVIVAL
;[AND]
;THREAT TO SURVIVAL
//defined probabilistically, using Schroedinger equations—
this is innovative//
//THREAT can also be defined in a simple traditional leaf-
branch-tree manner, as follows//
;THREAT
//stochastic processing of probability of non-survival//
;SURVIVAL
//continued EXISTENCE, probability thereof, inverse proportion
```

to THREAT—use Hidden Markov Machines, so that we also get the 'to' in 'THREAT TO SURVIVAL'//
;[OR]
;NON-SURVIVAL
//use HMMs again here//
//finally,
;IF probability of NON-SURVIAL > probability of SURVIVAL,
;THEN
;THREAT

Now all that remains is to actually write the code, which any of you can do in a few hours' time. You will realize, no doubt, that there already is an implicit ONTOLOGY to all this, which is what I worked out next, for the PI, which turned out to be its ultimate strength. My ontology—my Digitized Model of the World—my very own and very fast and powerful DMW—should have begun with the most basic of concepts or categories, that of EXISTENCE and NON-EXISTENCE, and that is how I started, my friends, and ended up in nowhere-land. So I slowly retraced—hackers, learn a lesson here, sometimes it is not enough just to debug—and realized that NON-EXISTENCE assumes EXISTENCE, and therefore was a lower level phenomenon, that it had to be subsumed under EXISTENCE. Martin, no, I don't want your comment.

Now I was through, and using neural networks, I could set up a field of operators for any object, any emotion, any concept, any thought. Thus you will see that every object in this model can,

be treated as a Black Box, you don't have to know what's going on inside
be related to some other object/s through pre-defined PROPERTIES or ASPECTS
clusters of objects themselves can be treated as a Black Box in relation only to one or more ASPECT/S (never equal to ALL ASPECTS—so it is open to being treated as non-Black Box object)
ASPECTS themselves are
// :) congratulations, hacker **OXXO**
SEMANTICALLY defined—ASPECTS are SEMANTICS itself.
//explicit mea coda

I first tried this on, no credits for guessing, on SQS herself, I coded the whole film—didn't bother about generating graphics, mind you, that's boring stuff—and then ran the the Alpha PI.

I was most surprised and elated when it returned the story of the film, and the approximate emotions that SQS felt at various points, the kind of villains needed and so on. In short, I managed to generate the same film through code, minus the graphics. I was so pleased, I sent a copy to SQS herself, as a kind of memento.

After this it was one long arduous pair of years in which I worked out all the details, and prepared the Beta, which I began to show around. I showed it to a friend of mine, an Inspector in the Crime Branch, and he was interesed to know if I could tweak the code to reconstruct crime scenes. Well, that was easily done, and that Beta version of crime scene reconstruction was turned into release version 0.1.

Since then my PI homepage has broken bones from the number of hits it receives daily, and now, of course, I have handed over the management aspects to friends who are intersted in making money for themselves, and occasionally for me, hahaha, sorry, Alan, for cutting a joke at your expense, hahaha. Unfortunately, what has also happened is that the police have taken over quite a lot of that management, and my beautiful Particulate Inspector is now being called the Private Investigator. Alan then floated a hardware company which started making chipsets designed to make it easier to run the PI, so now we are in the big league, and most youngsters and novices think that PI is a hardware thing, like, and some, I believe, think that it belongs too much to meat-space whereas it should properly reside in virtual space only.

But such vagaries, a hacker is used to.

Ladies and Gentlemen, you will have noticed that I started my speech without any proper address. That is because I wanted the world to acknowledge that hackers can, if they want, be proper, but choose not to be proper, and often get things upside down, or inside out. But watch me now, Ladies and Gentlemen. With the permission of one of our major investors, may I welcome that major investor herself? Ladies and Gentlemen, please welcome the one and only, SQS herself, the definitive Scream Queen, and I will also wait till the roar goes down, hahaha.

Well, friends, I am glad to inform you also that with all the money that the PI has made, I intend to set up a Harchive—a Hacking Archive, for which too, SQS has made a promise of a generous donation—she has promised us all the money that comes from the sale of the well-known SQiL, Scream Queen in Love t-shirts.

Finally, Ladies and Gentlemen, thank you for inviting me here to make a speech, and thank you for the HACKDEAD, the Hacker of the Decade Award. Thank you."

CODA

"Hey, where's the drink and the hash, man?"

The *Tout Autré* Killer

As they waited for the confession to be read aloud, at the request of the Killer, the Inspector saw that the Killer was weeping silently, deep inside his face. For most people except the Inspector, the face would have been merely hard and, in a curious way, calm. But the Inspector clearly saw the tears which would never be formed, that slight crease at the corner of lips that would never be there really, and most telling, the slight and simultaneous movement of chin, ear, and eyebrows which denotes the beginning of what cute women authors always call a "huge cry".

In itself, the face was curious because it was, almost, a common face. With minimal adjustments by a face-decorator, it could have been almost attractive. He looked like a Hollywood matinee idol, handsome, mature, understanding, with a patient desire which was most unlike the young boys that his victims would have known and wanted to love. Which, no doubt, was what the victims had seen and had gotten attracted to. Curious, the way people see and relate to what is only potentially present, never really there. The relationship between killers and their victims—of this kind of Killer especially—was almost like love, the Inspector thought. It was equally curious that this Killer had something in common, of all things, in the shape of lips, with the Russian serial killer that the Inspector had seen on tape. The lips were slightly down-turned at the corners, like a female porn-star.

The more the Inspector stared at the Killer, the more human he began to look. The deep furrows above his eyebrows, the muscular neck which belonged to a much younger man altogether, not this middle-aged man who was weeping silently inside his face.

The Inspector almost had to force himself to remember who this Killer was and what he had done, he had to bring to mind the mangled bodies of the young girls, sometimes rotting in water, once

underground, and the exhausting investigation which only was successful because, as happens more frequently that the Inspector would acknowledge publicly, the Killer had, thank god, made a mistake with his third victim—finally, he had found an easy target—his own student, unlike the travelling women he had picked earlier, who were not missed for days together. Naturally, when she was not seen for a whole day, people got curious, and her cellphone had his number. But he was smart, and there was very weak circumstantial evidence that he had killed her. Where was the body? It was only after fifteen days that the Inspector began to suspect the Killer. He had difficulty in getting a search warrant. Then he found a receipt for surgical instruments. Slowly, doggedly, like a good investigator, the Inspector persisted. He arranged for surveillance. He gathered enough circumstantial evidence. But what a top defense lawyer would make of it was anybody's guess.

The Inspector said,

"Why don't you just read it yourself and sign it, for god's sake?"

The Killer stared at him for a minute, and said,

"I am not St Ambrose."

The Inspector could only stare.

"Naturally, you don't understand. It's not your specialization. Ambrose was St Augustine's teacher, reputed to be the first one to introduce this reprehensible, this entirely solipsistic way of reading silently. This was a curse for mankind, which they never realized. Never mind. I have done what you needed, now you do what I have asked for. That, I think, you will understand. Also, since my confession gives you a solved crime, and a famous one, perhaps you will finally be considered for promotion. Think of that."

"Oh well, Professor, you can keep your philosophy things to yourself. You want it read aloud, it will be done. I almost feel sorry for you right now, considering that you will no doubt receive the death sentence. But I must say you've worked hard to earn it."

"Keep your thoughts to yourself. I have no interest in them. As for the death sentence, well, I was planning to kill myself after a few more anyway, so do keep your pity to yourself too. You are too ignorant to understand what was at stake."

The Inspector, though a little younger than the Killer, was too smart to respond to that. He knew that most people who said they didn't want pity usually needed it. But pity was missing from the range of emotions the Inspector could manufacture, feign, or have.

"Thinking silently again, Inspector?" The Killer was being supercilious again.

The Inspector returned the Killer's blank gaze to him, his own expression unreadable.

"I see. You are pretending to think. No? Perhaps you are trying to read my face? Understand me?"

After some silence, the Killer looked up again at the Inspector, and said,

"Do you know how to distinguish these, Inspector?"

The Inspector was looking away, out of the window. His assistant got up and left. The Inspector paid no attention. The Killer moved his hands, the handcuffs clanged against the table.

"Don't forget our deal, Inspector. I gave you my confession, all written out, in my own identifiable handwriting, now I get to get that read aloud. Only after that will I sign your no doubt badly typed copies."

"Yes. Of course, Professor."

"You are a victim of your own barbaric laws, are you not? Without my confession, you cannot prove anything."

"Don't be too sure, as I always tell you."

"Surety and certainty. Interesting concepts, don't you think? Especially if a man's life hangs by them? Especially if these words are not used figuratively?"

"We are talking a lot today?"

The Killer smiled radiantly. It was so bright that the Inspector looked away.

"I am only helping you."

"What?"

"Pass time while you find someone who is willing to read it aloud."

The Inspector was stunned. It was true that two people had taken a look at the confession and refused. He *was* waiting until someone agreed to do it, without him having to give orders. He had

settled the deal. He didn't have to keep the deal. He did not know why he was trying to keep the deal. He had enough, except the signature.

"Finally I get to the face of the man behind the Inspector." The Killer said it with vehemence and sarcasm.

"I think you might've made an interesting subject. But then, you would've been stronger than me."

"You mean you couldn't have killed me easily. Young girls are a different matter?"

"I must confess that I am equally sentimental about all subjects, young girls being no exception. It's just that I needed them specifically. Others would do, in other circumstances. But you haven't asked me how I knew."

"Knew what?"

"That you are waiting for someone to agree to read my confession aloud."

"Too late to kiss and tell, Professor."

"Let me have my fun, young man. After all, the only games I can play now are word games. Perhaps these are mind games for you. But I can play both these."

There was a curious staccato excitement in the Killer's voice.

"I knew because it's not easy to say aloud that I did this and I did that, see? Especially if that this and if that that are what I did. Something happens inside, to most people, when they speak as if they were someone else. I am only trying to explain in simple words. There is a whole technical vocabulary available. I don't think you will understand it. That's why, you see, the idea of reading silently was such a revolution in thinking. The process matrices of the subject function suddenly shifted. Well, that's the simplest way I can put it."

The Inspector stared blankly.

"Listen carefully. This is my philosophical confession. I have confessed the actions of which I am accused. But what I want to say will not come to light in that confession. Plus, we still do have to kill time, until your department produces someone stupid enough or tough enough to read aloud that confession of mine. So as I was saying—what was I saying?

"Oh yes, Ambrose. That is my latest work, by the way. I work hard as an academic, you know. In the last five years I have published three books."

The Inspector was getting annoyed again.

"So, when you strangled the first one, did you get an erection, or did you spout philosophy into her face?"

The Killer was struck by this unexpected display of temper, and started laughing. He said, laughing not too loudly though,

"Ah, but my dear Inspector, do you think you can tell the difference?"

The Inspector nodded to the Constable, and left the room.

He was furious when he came out of the room, and barked at everybody working in the main hall of the police station.

"Isn't there any bloody body bloody here who has the bloody guts to read the bloody confession?"

All his staff were stuttering and fumbling and stumbling over themselves.

"You. Do it."

"Sir, Inspector Sir! Please!"

"You are all making me angry!"

Silence. They were all silent. The Inspector felt defeated. If these were the people who were going to work for him, his chances were not very bright, he thought.

Bursting with temper, he pushed open the door next to him, and found himself staring at the Killer again.

"So, as I was saying, my dear, dear Inspector. As I was saying to you, as I was saying, as I was. Ha ha. Ancient poetry there. Well, not ancient really, but well. Never mind. As I was saying, one must be both, to be a philosopher, a genius, and an ass."

The Inspector almost hit him, then. The Killer in fact jerked his face as if to avoid the blow that he saw coming. It was then that the Inspector knew that before this particular story ended, he was going to hurt this murderer in ways that he did not know. He was an academic for god's sake, what did he know about hurting? What did he know about policepersons beating up a guy for his confession, and the guy is howling and the Inspector is saying, "Oh no, I don't want you to sing like this, I want WORDS THAT SING! I want WORDS THAT DANCE!"

Central Surveillance/Street43/CAM3/grab00045

PB was what had prevented his promotion—Police Brutality—but he liked the smell of pain oozing like blood from people who deserved it—and all the bloody animals in this world knew when they deserved pain—that was only when they had pained others. Even the dog and wolf gave in to morality. This professor here, this murderer, had killed, maimed, cut the bodies of kids who were, what, less than half his age?

"Alright, then," the Inspector said. He said it softly, and the whole police station heard it, beyond the walls, including the sentry who had been punished for laxity, guarding the prisoners who would never be able to escape.

They were all waiting, the Inspector thought, for this moment. Including the Killer.

"Alright, then, I will read it myself."

The Killer coughed, and said,

"So finally you see the point. It comes down to you and me."

"No!"

The Inspector had almost screamed, he realized. The Killer was smiling complacently. Time to take control.

Softly, he said,

"No. It comes down to you and the girls you killed."

The Killer laughed out loud. The Inspector, without realizing what he was doing, in a flash, hit him with the flat of his hand—One Must Never Leave Marks While Hitting The Accused—on the Killer's solar plexus. The Killer collapsed, as much as his chair allowed him to collapse. But he took sharp, deep breaths. He was good. He was in the greatest physical shape, more than any criminal the Inspector had known. Such types always got caught because they were tired. As had this one. But he was good.

The Inspector frowned. There was blood coming from the Killer's lips, which he was trying hard to keep sealed. He was worried, but he smiled, and said,

"Listen, now, your desire is being fulfilled. I am going to read out your confession. Watch me," he said, with an extraordinary calm.

⌘

"I, _____ you have to put down your name here, in your own handwriting—Professor of Philosophy—"

"I know. You can skip that part."

"No. You don't understand. I mean YOUR name. In your voice."

"You mean my handwriting."

"As long as you do it, I don't care what you call it."

"Yes, I see. Just get past the legalities, please. This is a matter of ethics, not legality."

"In full possession of my senses, and not under any form of coercion do hereby declare unto the judicial—"

"You have to say 'unto the world'"

"Same difference!"

"—authorities that I killed three women, most of them young. No doubt the court, and the judicial system still require me to explain why, my motives, my psychology, without which this confession would not be thought to be complete."

He almost spat the word "psychology" out of his mouth.

"However, I would have the court, and the general public—"

"What I have written out is an exact copy, to the letter, of the statement I issued to the Reuters woman, you know that?"

"—know that it was not a psychological, but a philosophical inquisitiveness which led me, step by step, to these killings, knowing only too well that in the world as it exists around me, at some time or the other, society will think it necessary to kill me. In retaliation of killing a few, oh, too few members of it. But I am glad that justice will only be meted out to me, and not to any other, and not to more than one member of the aforesaid narcissistic society."

What I have always been troubled by, from my childhood, if you like, is the undeniable and utterly incomprehensible existence of others. But they exist, and have to be comprehended. Having tried every which way, having tried every depredation, every heroism, every nobility possible in our times, I was forced by circumstance, and personality, to explore ways no more violent than a common atrocity, entirely forgotten, and therefore forgiven, in war time. It was after I killed the first time—and this time bodily mutilation was involved, as you already know—that I realized that the fact that they die when you kill them that proves that others exist. Now, please note that one is always doing this, but there is hardly a philosopher who has given an empirical, bodily, material proof that others exist. The proofs they

offer are merely logical, or merely philosophical, mired in the sordid history of theirs, and more often than not, entangled in their own lives, their own lies, and their own bloody psychologies. This is why Donne, a profound poet, had to say death thou shall—thou *shalt*—unhkhummhh—die."

"No training in English Poetry, Inspector?"

"No poet or philosopher has made little of death, because it is always others who die, it is always the death of others that we know. We can never know our own death. Death, in fact, proves that others, and therefore I, exist. But it never is my death, it is always the others' death. Therefore I decided to prove, in no doubt my own mediocre, maudlin, human way, that I exist. Every time I had a problem proving to myself, deep inside my head, where I am always crying and crying and crying and crying and crying and crying, that I existed, I had this urge, this demi-urge, this creative power that all of us possess, to kill someone else. I am confident that you don't know what I am talking about. Allow me to explain."

The Inspector paused, and drank some water, perhaps it was coffee that the Constable had got, he drank something from a jiggling plastic cup. It was lukewarm.

The Professor saw an opportunity, and opened his down-curling lips to say something which the Inspector cut off.

"The truth of the matter is, of course, that we, you and me, Inspector, and no, I will not exclude the beautiful human beings and relationships that I had with these women I killed, are very good killers. I mean, just think about it carefully. I did say I will not exclude those I killed. Given only minor differences, you will kill me, as they would have. I hope you realize that I am saying that there is no difference between love and murder. Many people have equated love and death, there is a tradition. But no, this is not the place for a disquisition on love and death. In short, I killed these women because I wanted to see what made them alive, and yes, I entirely and without hesitation admit that life is as mysterious as death, what made them tick. Not their biology, or their soul, no not in that sense. In the sense that I wanted to touch the heart of their otherness, and one cannot do that without empirically touching the hearts of others, and one cannot touch these without cutting open the said others. That is the

fundamental physical law which constrains us, and all our knowledge. Not even I could find a way to avert that law.

The first one was the most difficult, in that sense. There she was, anaesthetized completely, her breath barely visible, her pulse way below 50. She was merely asleep. So deeply, in fact, that I could cut her open, but I had only thought of a large knife, and I had not taken the bones into account, certainly not the rib cage. One forgets that women have rib cages. Of course one of the greatest mistakes in love is to embrace people from the front, put your ear onto their chest to hear the heart beating. What one must do is to put one's hand inside the chest and touch the heart. I was also worried that she might, because of the pain, wake up. Actually, the first time, I did not really know what to do. I lifted her up—she was heavier than when she was conscious—and put her on the floor in my large bathroom. Then I spent quite a long time cutting her open. I realized that next time I would have to read up on surgery. As it happened, I managed the first time with some effort. And then, there it was, the heart barely beating. She was going down very fast. I managed to put my fingers through the gap in the ribs and touched that beating heart.

It was like what religious people call an ecstatic experience. It was what Augustine, for example, would have called a revelation. It was a trip to out-trip all trips. Then within seconds, she was dead, and I cleaned up the mess, with mops. It is very strange, but after she was dead, it was easier to cut her up into suitable parts, so that I could scatter them across the City. It took me six hours just to clean up, and three days to get her out of my house completely.

I did not let myself think about the bliss I had experienced, and the things I had learnt when I touched her weakly-beating heart."

The Inspector did not look up, and so did not know that everyone in the room was staring hard at him.

"The second one was easier, because by that time, several months, almost a year later, I had managed to read up on human anatomy, especially female, and knew more about what to expect. But the thrill was exactly the same. It is such a strong experience that repetition does not dull it."

I am aware that my philosopher friends will say that I was giving in to Hegel's Joke—allow me to explain, after all, I AM a

philosopher—of the man who wanted to buy fruit, and refused to accept apples, and peaches, because these were mere examples of "fruit", not "fruit" itself. I wanted to understand the otherness of others, but here I was touching mere examples of otherness. But Hegel's Joke is ancient, and does not take into account my convincingly demonstrated concept of emp- empi- empirical materiality. In this demonstration, the conceptual distance between concept and example is made to go away. I am sure my friends will remember that. So I did that again, this time I had proper surgical equipment too, so it was easier. Her back was exquisitely shapely, so I opened a path to her heart from her back. It was a little difficult to find it, but I found it, touched it. It was beginning to weaken, but it was beating. Less trauma, you see, because there was less flesh to traumatize. I would have it understood that there was not even a bit of sexual desire in what I was doing. While I had her opened, I also looked at her spine, and touched it. The spinal chord is not very nice to look at. It looks like a serpent hiding inside a human body. But there is nothing as thrilling, as life assertive, as touching as touching somebody else's beating heart. With your own fingers, and this time, with your full hand, to hold it, almost, in your hand, still beating. She died soon, as I watched her heart beat, and this time, I cut her heart open to see if there was anything else I could find. There was nothing but just muscle and blood, of course. I cut a part of the muscle, just a tiniest slice, and put it in my mouth. It was as if I suddenly knew all the salted secrets of our civilization. This is how civilization began. With people ritually eating their dead, loved ones. The taste of human blood, and muscle, takes you to the very origin of human existence. It was, I must admit, a sacred moment.

I could not, alas, wait to taste human flesh again. As all of you know, psychopaths like me make mistakes, always, because they hurry. I too did. After all, I did not have much previous experience of the enormous hunger. I cannot even describe it. It is as if something preternatural, something divinely spiritual takes hold of you, and would not let you think anything else, or eat or drink anything else. I wonder how the ancient societies controlled this hunger. Perhaps that is why it was always ritual eating of the flesh. It would be

forbidden to eat human flesh on other occasions. I did not have ritual to make me control myself, and so in my hurry I took the next available woman—a somewhat dull and uninspiring student.

This time, I cut her heart out, and put it in the microwave for a few minutes. It was quite tasty. I had finally managed to culture myself into eating cooked flesh.

This is smaller than I thought, the Inspector said.

Aha. You want more? I think I have caught you there, you hypocrite. Oh, you are like a brother to me in this!

Let's cut the long story short. Here is the last bit. This I do confess—

Put your name and address here.

The Killer was smiling. He said,

See how brutal you are sounding, Inspector?

Finally, the Inspector lost his temper. He moved fast to the Killer's table, and reaching out, gripped the Killer's upper lip between his thumb and forefinger, and twisted and pulled. The Killer moaned, and whimpered.

Now you bloody know that others bloody exist also when they bloody hurt you, you bloody idiot. I am going to let go now, and I don't want to hear a sound from your truly bloody mouth until you have signed.

Sign here _____ the Inspector repeated.

�֍

The Kaffkett Korp

building

is not exactly in the centre of the City, nor secluded into the suburbs. It is not accidentally but essentially immense, though it pretends only to be one of the many high-rise, non-transparent perspex buildings in the City. Almost everyone in the City knows, though, that it is the only truly remarkable building in the whole City, because Kaffkett Korp is the biggest employer, the biggest company, biggestestostallone firm, biggestest multinational, qua multinational, and it can be said again, qua qua qua multinational. Even Coca-Cola and Nike, and Toyota and Sony can not compete with that. These are mere national offices: Kafkett Korp is Main Studio.

The building is about seventy storeys high, very slightly narrowing at the top. It has two openings, or closings. These openings open and these closings close, mercifully, at different times. One is its mouth, into which about one and a half thousand people enter in the morning (in the 7:30 to 9:00 am window, depending on seniority, a very tight and pushy rush), the other is a tight sphincter muscle right beside that mouth (the muscles stronger than the mouth), through which the same one and a half thousand people exit in the evening (in the 7:30 to 9:00 pm window, depending on seniority, a very tight and pushy rush). The other employees, who choose to work flexi-hours, live in pancreal, expensive apartments in the building itself. Naturally, most of the time, they work in their offices, or in the riche-niche comforts of their home computers and home theatres. They work. Like clockworks always work.

People who enter circulate inside the building, sometimes sitting in their cubicles, or lazily sauntering to other cubicles for a quick PSR (pre-Shoot Rehearsal), or to coffee machines, or to the ultra-antiseptically clean, ultra-moral unisex toilets. People are like blood. They circulate.

The Kaffkett Korp is so big and influential that it has a VoM policy. A VoM policy breaks down into Vocabulary of Management. The

Kaffkett Korp, founded partly (he had only a 4.57998796579 share then, a hundred years ago), by a Professor of Philosophical Elements of Ancient Fluid Dynamics, is still aware that Words Matter in Business [WMiB (we are yet to come to WMiBII, but that would be another story, maybe, may not be)]. It follows that the words that other companies use to understand themselves matter. Therefore, the words that Kaffkett Korp uses to understand itself matter. Therefore, while Other Competitors are still fiddling with the SnZSOFMBOW, the Sun Zu Style Model of Business Of War, Kaffkett has adopted the Film Industry Model [made known to its employees as H_S/M (Hollywood Shooting Model)], anything that is tried out is called a pre-shoot rehearsal, any resolution that is accepted is called a take, any hesitation is called camera-shyness. All the cleaners and automated machine sweeps are called Light Boys, every presentation is called a rehearsal, and if it is liked, it is called a Can-It. When a product is finally "launched", the moment is called a Premier. Everything, each frame, each fame, each and every utterance, is, naturally, a Representation. Especially, each Frame. Being Framed is an Honour. Obviously, if a Corporation like Kaffkett chooses to Frame You, You Must Be Important. If Kaffkett Korp framed you, and threw you out, others will hire you before you were out of Kaffkett building, before you hit the sphincter muscle and it pushed you out. Most other people devoured Kaffkett Korp multinational shit anyway.

Kaffkett has a finger in every pie: literally every pie that is made in this world is made in either a derelict electrical oven, or a gas-burning oven, or a microwave, and Kaffkett has either made that oven, or has made some part of it, or has made the pie itself for one of its employees' birthday. There are enough employees in Kaffkett, so there is always some pie made in the building to celebrate the birthday of this or that employee. Pie is an Everyday thing. One can eat a fantastic pie here without knowing the person whose birthday it is today. We Are Celebrating Your Birthday, Dear Employee. Thank you, Dear Employee, for this wonderful opportunity to serve you PIE. (The kind of pie is determined by summing up the numbers of the employee's birth date, or sometimes, his salary, and of course, the larger the last number, the more decorated the pie is.) Pie, as every schoolboy knows, is a number that stretches to infinity.

Kaffkett is also Kareful, quite often, to make sure that the letter SEE is NOT used to denote, indicate, deictify the sound K. There was a time, a few years ago, when:

Kaffkett ekshuali enforsd speling riforms. Dokuments bigan tu luk veri speshli Kaffkett styl. Most peepl bigan to sirkulet insyd th bilding with slytli konfusd woks, ironed to hide the confusion.

Kaffkett reverted to normal spelling, however, because komunikeshn with other companies bekame quite an issue. Most employees have now got used to the idea, and do not frown at unexpekted Ks popping down, for example, in words like Kasket. One of the biggest changes that were effected during these reforms of course related to employee names. Kaffkett decided to emphasize the letter K, and therefore all employees were called K-something. That something was soon reduced to K-numerical, usually a cardinal number (the Kaffkett systems cannot, in spite of all the computational progress, handle ordinal numbers). To remember someone else's cardinal number was thought to be a wonderfulgesture, and bosses always made sure that they knew and recalled everybody's cardinal number. Most people, ordinally, accepted whatever number they were addressed as. Amongst employees themselves, a change from the cardinal number to personal name was thought to be an act of flirting. The employees did not mind, for names were too personal anyway, too intimate. Moreover, all of them, the people themselves, looked alike mostly, for Kaffkett had an implicit "look code". It was never mentioned, but if someone turned up in a red shirt and blue tie, there was an unusual frisson in the air the moment s/he was seen. Grey shirt and white tie were the in things at Kaffkett. The bosses encouraged this implicit look code because, in fact, it was one of the things that had evolved among the employees themselves, something the Costume Designer had not set up.

⌘

One fine morning, K-29 was woken up by an insistent knocking on the door. It was his day off, and he had planned to sleep till late. It could not be the landladies he thought, it was too early for the old women to start knocking on his door to feed him whatever they had made that day.

He opened the door to find a courier thrusting a packet into his hands, and then holding out a receipt to be signed. He could barely focus on that small space meant for his signature because the packet was from Kaffkett itself. This was most unusual. Kaffkett could get in touch with him in many ways, the most common being a circular, or an instruction, opening up the moment he logged into his computer. They could ring his phone.

"Aren't you going to open it, my dear?"

The courier had left. He was facing the two landladies. In their eighties, they behaved as if they were still twenty-five and still celebrity film stars.

"He seems worried!" the other said.

"Shall I open it for you?"

"Don't you poke into his packet. Let the young man be."

"I think he needs to eat something. He is looking thinner than ever."

"Shut up, you idiot! It is the fashion of the day. And don't you forget how anorexic you became for that shoot."

"Aha! I won't forget your silicone breasts either! And you didn't even get the award."

"You! Who do you think I am? SQ Sajnovics?"

"Don't talk dirty with this young man present. Look at his lips. They are trembling."

"Hips don't tremble."

"Hips? Did I say hips? Of course I know hips don't tremble. But his hips also could be thin, you know, like his lips?"

"He needs to shave too. And some exercise."

"Let's give him something to eat! He will be hungry after his exercise!"

He retreated into his room and closed the door shut. The two women were laughing still, looking at him with an affection that he found himself unable to reciprocate.

It was his rightful holiday. He did not open the packet.

The next day, he found himself facing his head, as he turned around after closing the door.

⌘

"Do you see this plant, my dear K-29?"

K-29 looked around for a plant, groggy with sleep. He wasn't awake yet fully.

"This plant, my dear K-29, bears an honourable name. It's called *Encephalartos horridus*. That is its Latin name. Doesn't it make you shiver? Such an ancient language! But the plant, K-29, is older even than that honourable language. This is a plant of the cycad family. Cycads are older than you might think. For a long time they have been known as fossil plants, because they are very old. Do you know how old?"

A strange discomfort was slowly welling up in K-29. He looked at the not very large plant, its spiky leaves and the main head with spiral markings.

"I ask you again, K-29, do you know how old cycads are?"

K-29 wrenched his eyes away from the plant to find the head standing up close to him. He shook his head to say no. He felt completely tongue-tied.

"The cycad family is as old as the dinosaurs, K-29."

His number was uttered with affection, almost like a caress. A tingle went across his spine, the kind that always comes before sweat begins to form on the forehead.

"This particular species used to be found only in South Africa. It has its own ecological niche, basin of attraction, its own eco-space-time. I have paid about a million to buy it. It is extremely rare. I provide it with artificial dryness and heat. I have the male of the species at home. I pollinate this one with my own hands, since natural pollination is not possible. When she is ready, indicated by a slight change of colour in the head, and a slight opening of the cones, I bring pollen from home, and carefully insert it in the openings. Do you notice anything about the cones, their spiral arrangement?"

K-29 stared hard at the cones, their spiral arrangement.

"I am not sure, but you might know, K, do you think the distribution of cones is a Fibonacci series? Do you think—you know the Fibonacci series? You know, 0,1,1,2,3,5,8,13,21? And the golden ratio? The Fibonacci series is found in designs in nature. Are you a

nature lover? Do you go out to jog in the park? And do you know that a minor change in the Fibonacci series gives us Lucas numbers?"

Finally K-29 was forced to speak, as much by the situation he found himself in, as by his happy memory of running and breathing hard last morning.

"Yes, I jog in the morning sometimes."

"Good. I knew it, of course. We like to keep track of our own people, you know. In any case, that is my job here, as Set Producer and Manager, as you no doubt know. So, as I was saying, it is entirely within the range of possibilities that this plant displays one of the secrets of nature: the Fibonacci series/Golden Ratio. But this specific plant, this one here, has another secret, and only I know it. I am going to share it with you. Do you see anything in the tips of the leaves? No? Let me tell you then. Normally, the tips of the leaves of *Encephalartos horridus* are very hard. Get up. Touch them.

"Notice anything?

"These are not very hard. They won't hurt anybody. I have taken out the horrid aspect from *Encephalartos horridus*. Do you want to know how I did that?"

K-29 looked at his boss.

"Every week, I give it a glass of the best Bordeaux I can buy. This means the best Bordeaux there is, of course. Every week, I measure the hardness of the plant, and prepare a dose. I inject the Bordeaux at its base. It takes about a day for the tips to soften slightly. Oh, do you like wine yourself? Bordeaux? Perhaps something else? Amontillado? No? I understand. You are young, and care for your health. That is good. Anytime you want to explore wines, let me know. I am told that I have a good collection. You must come home some time, by the way. Incidentally, as it were, qua incident, you should be going now. You have quite an adventurous life ahead. You should move. Keep moving, as the traffic signs say. Thank you so much for this wonderful conversation—I mean your tremendous interest in my cycad—*Encephalartos horridus*."

K-29 thought he had a charmed life, because he thought life was charming. He went to his desk. He thought he was going to his desk after that strange speech by his boss about some plant to which he fed wine. He found himself in a section not his own, which meant

the wrong section. That was not so good, he realized, from a Set Manager's point of view. Moreover, this was a very strange place. In the distance he could see a clothes line and a woman hanging clothes on it. He heard a baby cry. To the right of him, he saw a balding young man, with really weird ears, pointed and large, working at a machine. He looked up at K, and the look reminded him of something. He couldn't tell what machine it was. The balding young man looked at him and his mouth fell open.

He knew he had done something wrong somewhere, especially with that still—hushhushhush—unopened packet lying on his bed. He hadn't opened it, he realized now, because the sticky-tape on the flap had felt like an insect's back—a beetle's back—all smooth and polished, hard and brittle, and all, all, entirely inhuman to the touch. He felt as if all his limbs were writhing to get up, and he couldn't.

He was in the riche-niche apartments.

"You are lost."

A statement of fact, he admitted with a nod. He was scared to speak. His throat, and he feared his mind as well, was seizing up.

The woman had white clothes on her, almost like a caring nurse. She also had a badge which had a name that he couldn't read fully. It began with p, and there was an h somewhere, or perhaps an inverted p. There was something terribly wrong with him. For some reason, he thought that an I was missng.

"Oh my god, you are claustrophobic. Come with me!"

He was at a lift and the angel was pressing keys in some sequence he did not know.

"Once the doors close, please don't panic. I am sorry but the lift is the quickest way to get you help. Sit down, and put your head between your knees. Help will be here when the doors open again." He wanted to say that help should be there when he reached there. But his throat was seized up, he couldn't even breathe with the doors closing with a hussssh.

When the doors opened, there were two outside, who thrust their very large hands out to pick him up, and said,

"Let's go."

⌘

"BB," she said, "He's waking up!"

"Go, go," the other one said, "get the clear soup."

Somebody had done something to him, he was sure of that, though he couldn't say, or think, who or what. He was hungry.

The hard metal of the spoon, hot with soup, made him open his lips. Scalding hot soup entered his mouth.

A hot intake, a hot exhalation.

He woke up coughing, gagging; everything had gone the wrong way down. All his limbs were aching as if he had been hauled through a KDV re-re-cycling machine. He looked away from the old woman who was looking at him with worry, and his eyes focused on the yellow packet which probably was the source of all the trouble. He made a move towards the packet, but couldn't quite finish the movement, and sat up in bed instead.

"Oh good, now you are really awake," she said. "You must eat now."

"How?"

"Two men brought you in, you were unconscious. They dumped you on the bed and went away. They did not look like nice men. Who were they?"

"Set—security from my office."

"Are you in trouble?"

"No, why should I be? I have done nothing."

"I did a lot of nothing in my life. I was always in trouble. Ask her. She will say when I say I did nothing I mean I tried to do something that I shouldn't. But she remains the good homely woman that she played on screen. I am different. I am much more like you, young man. So what if I am old. I mean older. Silicone does things to you, you know."

"Oh, stop trying to seduce him, poor thing. Get up from his bed. Let him have his soup now."

The one called BB cackled with laughter and got up from his bed. He had to feel grateful for what the two were doing for him, though until now he had always found them intrusive and obdurately friendly conversational. Women, he thought, were nice and helpful. While thinking that, he collapsed again.

"Like water," she said.

"Like leaves," the other said.

"Like something," she said.

"Like everything," the other said.

"I am not sure about that. Speak for yourself, BB."

"You know I love you. Come, give me a beer-hug."

"Your mouth is stinking, you old hag."

"Like something," she said.

"Like everything," the other said.

"Like leaves."

"Water," K-29 said.

They gave him water.

"Which, in our case, we haven't got all these years, working so hard."

"What?"

"Leaves." She said.

"Water." He said. Nobody heard him.

She took off her shoes. And sat pensively looking at them.

"BB?"

"You don't know how much my feet hurt."

"You should've thought of that when you were sticking them up in the air so many times."

"I'm talking about gods. Their feet hurt from waiting for the final moment."

"I'm talking about your promiscuousness."

"Same thing."

"Ah, but you should be saying same difference."

"I don't have your education."

"Nobody else does. I went to the j-unmkgh-choicest school, choicest college, choicest Goblin University."

"You shouldn't have waited, you know."

"Look who's saying that."

They were both silent for some time. Then he said,

"What kind of university is Goblin University?"

"Ah. I will tell for the thousandth time. Goblin University is where they teach you to hob."

"What is a hob?" K said.

"A hob! Of course, that's a long story that I will never tell until you learn to gob—gobble up all this food we have made for you, you silly young man."

"No, tell me. I insist. I won't eat if you don't."

"Statement of fact, ah? Well, one can't resist responding truthfully to a statement of future fact untested, unverified, unexamined. A Goblin University, my dear child—you know you are sixty years younger than me? Anyway, a Goblin University as I was saying—

"—is a university where they teach you facts like how hobbits were actually only a cross-bearing species gotten out of an untimely—hmmm—let me get the word right, ahhh, yes—meditation, shall we say, perhaps we should say mediation—between gobbits and hoblins. Gobbits are nice people who are always gobbling up food, as you should be, it's getting cold. That's all I will say, because that is all I remember learning. Hoblins, I remember, were a people who lived in, on, off, for, up, down, left right centre, up down the great urban outdoors of the City. They were called that because they always hobbled, you know. Poor homeless people. I had the misfortune to act as a homeless woMan, in that failed attempt by Patchowsky to make a movie. Now why silly painters are always wanting to make movies is beyond me. I speak with sixty years of experience of art and the movies. Take Botticelli. Did he want to make a movie? No. Picasso? No. That wonderful young woman who died last month, did she want to make a movie? No, sir. Painters don't know a thing about make-up you know."

"Your silly cone-shaped breasts fixation." She said.

K-29 no longer knew who was saying, or saving saying what, when, how, why, who.

He was already unconscious, and killing the landladies with an axe, in his dream, that he did not have.

⌘

The Small Packet

When he opened the packet, it burst into flames, he heard the burning as blames, that's how fires end, in blames, and not in flames, and through the force of this conjunctive he knew that that packet

was meant for him, and only him, like doors that open only for certain people. The message, meant only for him, had self-destructed, sending out a wailing dog radio signal that he did not hear.

⌘

What Really Happened

They made the rather long, quite detailed, story, rather short.

They came for him the next day, as surely and absolutely as temptation came to Novikov in an ancient Peter O'Donnell novel, as he, Novikov, discovered a gold seam in the Russian satellite photographs, leading to his torture and death. He died, perhaps, like a dog, under some edict that he had not read, which made his death alright for law, for they quoted the ancient all-prevailing all-pervading principle, *ignorantia legis neminem excusat*, ignorance of law is no excuse, excuses none. The two didn't have to knock. The door was open, because the landladies, whom after all he had not killed with his non-existent axe, were getting him his brunch;

he found two strange faces leering down at him,

they said, in musical, falsetto, fugued unison,

"Let's go, let's go,"

"lessgo, lessgo,"

He did not move.

❄

The Case of the Hollow Golden Goddess

It was for about six months that the Inspector had not slept well, had woken up early morning, finding himself unable to sleep. Three months ago, he had started taking sleeping tablets. That gave him an artificial sleep that he found very discomforting after waking up. It was not that he had been alone in bed for quite a few years. It was not that there was no breakfast made by his wife waiting for him when he was ready for it. He had gotten over that in two days after she left him. It was that he had a recurring dream, which he could never remember. This was a state of dreaming that you were dreaming, while feeling wide awake, ready to get the gun from the spring loaded holster and start shooting, it didn't matter who, whoever it was, was trying to kill your partner. He had survived these things, in dreams, and in reality, whatever that was.

The bright light it was, that woke him up, but he didn't know that, the second he woke up. He woke up slowly, happily, with a sense of security in his solitude. He lay there, curled up, clutching his blanket with his left hand, his crotch in his right, the sunlight falling on his butt and his thighs, warming them. Vaguely he remembered some image of a man asleep. Guns, criminals, murderers were forgotten. He did not know who he was. He was in state of happiness after several years.

He doesn't even know what his phone number is.

His phone is ringing.

He has confused the bright light with the ringing.

"Keep the senses apart. Don't confuse them. You'll end up dead that way, without knowing," he says to himself, louder than he meant to.

"Hello."

"Judge!"

"Essss." He said.

"Judge? Are you alright?"

The prim and proper Sub-Inspector.

"Yes, just waking up, thanks." To make sure that the point reached home, he said again,

"Yes. Thanks for waking me up."

"Sorry, Judge Dee, but—"

"When are you people going to stop calling me that?"

"Sorry, sir, but—"

He almost screamed into the phone, "Noooooo!"

"Yes?"

"We have a murder here."

"Where is here, at this point in time," he spoke his thoughts aloud.

"Shining Star Apartments, sir."

"Who is it?"

"Unidentified male, sir. Possibly Chinese."

"Business, or martial arts?"

"Looks like a businessman, sir. But you know how—it is."

"Alright, alright, I will be there in half an hour."

He had a quick bath, he dressed, he took his keys, his gun, locked the flat; in the garage, he got into his car, and then he drove. Then he lost his way.

He was still feeling residually happy. Still trying to retain that moment when he had woken up and felt happy.

When he realized that he had lost his way, instead of stopping at the signals, and finding the rare traffic policeperson and asking him or her, or someone else, he speeded, because he was getting late. On the Arterial Road, already a few automated cars were moving. He knew they would sense and avoid him. He hoped to god that these new Micro/Ford cars were as good as the brochures said. Soon, he was assaulted by a traffic chap, who stopped him: risky, gutsy guy, new cop, taking risks, slid his bike right in front of his car. He had to brake hard to stop his car from kissing the cop's bum. As it was, he had kissed the bike's bum, barely touching it, and the traffic chap was mad.

Even before he had got the window wholly down, the cop was saying, all polite anger,

"Your papers, mister."

"You are supposed to say sir."

"Your papers."

"I am Judge Dee."

"Really?"

"Truly."

"And I swear by the sacred Penal Code of this Great Nation that I, the Prime Minister, want to see your papers."

Like all apprehended traffic offenders insulted by traffic policepersons, the Inspector could not find anything else to say but abuses. He didn't utter them, of course. He knew better. All he had to do was to flash his ID, and this little honest chap would be all jelly. He would now flash his ID, swiftly extracted from his pocket. The only problem is, he realized, too late, as he put his hand in his pocket, he had forgotten his ID. He cursed himself. The traffic chap said,

"Yes, the Judge has forgotten his ID. But the PM has not forgotten the rules and duties and the fines, nor the receipt machine."

"Look, sir,"

Judge Dee had to say that rather quickly, because it was difficult to call someone else sir.

"I am in a great hurry, I am an Inspector, you are too young and new to understand, so just tell me how much the fine is."

"Fifty, your honour, for not carrying papers."

The Inspector thankfully found a fifty in his wallet, and handed it over.

The traffic chap quickly punched his machine which spat out a receipt in due form, the pinch rollers pinched, the bearings bore, the wheels turned, the printer printed and the piece of bad paper emerged in less than a second.

"How do I get to Shining Star Apartments?"

"You are seven crosses wrong. Take the first U-turn, go back seven signals, at the fourth signal, take a left. It will stare at you as you turn. You cannot park on the left, not today, so you go all the way, take the first U-turn, and then you can park anywhere—today is P2. You don't want another fine, now, Judge, do you?"

The traffic chap thrust the receipt through the window, and deliberately, slowly, moved his bike away, pretending that is was badly damaged. It takes a whole minute. What is most humiliating is that the traffic chap is laughing to himself, barely able to conceal it.

Of all the possible things that could happen to him, this is the least expected. The City is moving towards automated cars. Soon the traffic police will have to be given other duties. It has to happen the way it happens, he sighs to himself, and focuses on driving. He is barely able to stop speeding. He doesn't want the doctor to see the body before he does. He hurts his calf muscle, sprains it almost from stopping himself from speeding, he is not used to pressing the accelerator with his toes. Usually, he has the police car, and he always turns on the light and the siren, and the Good Citizen Gobbits of the City always make way for him, so he is used to stamping on the accelerator with all the force that he can muster in his heel.

<p align="center">⌘</p>

He reaches the Shining Star Apartments annoyed, furious, anxious, angry, feeling stupid. Welcome to Gobbit Land.

A constable salutes him and says:

"The left on the lift is waiting, sir."

He takes time to understand. Then he feels better. He feels himself, almost.

"Constable, get yourself checked for dyslexia by the psychologist, soon as you can."

"Sir?"

"You might have, you know, Spoonerism or, as they might say, dicklexia."

He only sees the constable smartly saluting with an uncomprehending expression as the doors close.

The constable is a smart one, he decides. The ones with linguistic disorders are usually good and smart in other areas. Like him, before his wife cured him. Thankfully, he continued to be good and smart even after he was cured of his language problem. The constable has already pressed the buttons for the lift to go where he has to go, and kept the doors open. He doesn't himself know how to do both these things at the same time.

The doors open against another door, which is flung open, and the Sub-Inspector smiles at him, and jerks his right shoulder—a mere sketch, no, a mere hint of a salute—but the smile is genuine enough, so the Inspector has never really minded that the Sub-Inspector rarely salutes.

Then he is on to the crime scene, but the Sub-Inspector says, in his ears, a mere whisper, smiling,

"Must you always come smiling like this on to a crime scene? There's a dead person here, you know, like a real, and really dead human being?"

This is the first time that the Sub-Inspector has tried to be intimate with him. Intimacy at the time of work always annoys him.

He says,

"Police fight crime. No crime, no police. Crime is there before the police. I am glad I exist. You follow me, Sub-Inspector? If there is crime, I have work, and pay, and salary. I am glad there is crime. Now, will I be allowed to have a look?"

The Sub-Inspector does his shrug thing again, but also does something with his right wrist and trouser pocket. The Inspector files it into his memory, but doesn't ask anything. Then he is crossing into the apartment. He stops at the door. He is already getting into his gear. The wheels are turning smoothly, the teeth meshing with the smoothness of cuts in a L'Oreal advertisement.

"Who discovered this?" The Inspector asks.

"Sorry, sir, it was an anonymous phone call."

"Traced to?"

"Sorry, sir, a public phone booth."

"Traced to?"

"Three blocks down, left, card-operated, sir."

"Private card?

"No sir. Public. Untraceable. Not discarded."

"You are sure it's murder?"

The Sub-Inspector smiles, and says,

"Yes. Take a look for yourself if you think I can't figure that out! Step into the room, please."

He pauses at the door, closes his eyes, concentrates on the task ahead. He empties his mind of everything possible, to bring his senses to an altogether higher state of alertness. He is utterly devoid of memory at this moment. He must look at everything with fresh eyes. He must forget the number of crimes he has solved. He must not see anything familiar in the crime scene. Each crime is new. Each one his first case. This is his game. He is the best. That's why he is here, and Inspector.

That's why he continues to be Inspector, refusing promotions, or other forms of advancement in his career. This first crime scene is his career.

He stands in the door, eyes closed. He does not know that others are looking at him as if he was about to perform some awesome magic. They hold their breath.

Perfume. Rose petals?

Beneath that a faint almond smell.

He makes a sound, directing the waves through the door ahead of him. The sound moves through the room, and does not return to him at all. Big room.

He opens his eyes. The room is smaller than he had thought. Bed on the right. Only one other door. A single room apartment. Top floor. There's a skylight fitted into the roof. Light streams in, he follows the light, and finds the spreadeagled body. Thin, muscular. Work-out artist? Martial artist? Long hair sticking into the large wound on the skull. Only somebody else can deliver a blow to the back of the head. Large shapeless blow. Not your standard cosh, nor your butt of a gun, no steel rod, no weighted sock. No handy heavy object. Something round, big. Left hand folded under the body at an angle impossible in life. Broken at the wrist? Before the blow? Or broken by falling on it, as he was dying? It's been known to happen. The bone structure holds you up only at certain angles, relative to gravitational pull, at others, your own weight, which is to say earth's gravity, breaks your very own bones.

He steps into the room, stops again. He can hear the others breathing heavily, can feel them gesturing to each other silently. Bed. Red bedspread. Curious fold in the middle, stretching from the other side to this. Pillow missing.

Wooden slippers beside the bed, one standing on its thick side. Monk, not martial artist? Artist? Plain artist with a fixation for austerity, ancient custom? Wall opposite has a Chinese painting, mounted on rice paper. Shit, he says to himself, I don't know anything about the Chinese. Wall in front has nothing.

They have been around for sixty years, and I know nothing about them.

Know nothing about Chinese painting either. Must ask J. She should be back soon. She is "relating comfortably" to a China expert currently. Half Chinese herself, this expert.

Painting shows mountains, trees, and there is a red mark of some kind on the right hand corner. Ink. Not blood.

He goes closer to the body, and looks down.

Yes, Chinese, male. As yet Unidentified. Someone will know him.

Lips drawn back. Expression inscrutable, as always in a dead body, and in Chinese, as far as he is concerned. How I wish I knew more about this mess, he thinks. A dead body. Yes. I know this.

Hello, death. So I see you again. The more I know you, the better it is for me.

Silken coat, long hair, rubber banded, but the band has gone somewhere. It's loose all over his back. Right hand is still trying to grip something. Make sure the Forensic Sensing Women take a closer look.

Silken trousers. Black leather shoe on one foot, the other?

There, between the painting and the bed.

Just came in, got bonked on the head, died.

No. Not convincing. He had just come in, was taking off his shoes, got bonked on the head. Legs particularly muscular. Foot. Sole of foot looks quite hard, but not dirty at all. Of course not. He wears shoes, doesn't he? Where *is* the single sock?

By now he has sensed that the Forensic Sensing Women have arrived, and are making a fuss about him being already inside. Women, he thinks. Why this generation of women was so good at Forensics is his next case. Hopefully.

He pushes himself upright, he has been sitting on his haunches, and says,

"Okay, okay, all yours, ladies. Control your necrophilia, ladies, be gentle with him."

They heckle him, as they always do, mentioning a number of his own body parts, and what they would do with them when he was found dead. He goes out. It really is the Forensics' scene. He had only wanted to assert himself in the face of yet another murder.

⌘

The Forensic Sensing Women are thorough, he knows, and so will take at least sixteen hours to say anything. It is now—he looks at his watch—ten twenty-five in the morning—had he slept that

much? He blinks his eyes, wishing he was still asleep, because now he has nothing to do. But he has, and he has known it all the while, almost.

He turns his head a little to make sure that the Sub-Inspector is with him, and says, intimately,

"So show me what you have stolen from the crime scene."

"Sir?"

"Take your right hand, put it in your right hand pocket, which you will find on your trousers, then take out whatever it is that you have put there."

"Sir?"

"Come on."

"There's nothing, sir."

He stops. He turns. He sees that the aforesaid right pocket is bulging with something. He slaps hard there.

There is a not very loud *plop*! and then whatever was bulging is not bulging anymore.

Then the Sub-Inspector is repressing his first giggle, but he is also overawed that he was caught. Then he takes out something from his pocket, holds it out for everyone to see. The Inspector does not like it.

"Sir, this is my daughter's balloon, sir, which I was blowing up while waiting for you. I am sorry, sir."

<div align="center">⌘</div>

Having done his other duties, like pushing and popping files down the huge mainframe, he is now waiting for a call from the FSW. It is now four-thirty in the morning, he has had his sleep, his breakfast, his tortured sleep, his second breakfast. The first could have been his dinner, he is not sure. He only remembers waking, eating, sleeping, waking, eating. He is rearing to go. At the same time, he is thinking of the only person that he really wanted, the one who had first called him Judge Dee. They used to be police together. She was the sharpest of shooters, but she was now herself dead of a gunshot. Her gun had, that day, that moment, snagged against her bra-strap. He had told her not to use the shoulder holster in that manner, under her uniform shirt.

He didn't want to remember, but it all came to him with cutting clarity, a knife slicing tomatoes, rapidly.

He was too late. He saw her plucking at her bra-strap to release the gun, reached for his own, and shot the man, but then, the man had already shot her. Instead of him.

⌘

Seventeen hours. Unusual. As he opens the fridge door to put back the juice, the phone rings. He drops the pack, and goes full stretch for the phone.

"Dee?"

"Oh yess."

"You have a problem."

"Tell me about it," he says.

"It's a murder."

"I know that."

"Yes, but you think that somebody bashed him on the head, and he died. No. We made doubly sure, it is death by poisoning."

"What?"

"And we don't know how it was delivered."

"What?"

"Well, we found a strange substance in his blood, right, so we think it is poison, it's a very strong alkaloid anyway, but not any of the known poisons. Known to us, up front, easily. Now we are, no thanks to the size of your brain, biceps or balls, looking into what kind of poison it is. Which we should be able to identify the properties of, but we can't tell how it got into his blood. There is, for example, no poison in his food, or stomach."

She was being rude. She was angry herself, at not being able to give anything more, he thinks. That reassures him. Once they bite into something they will never let go. Proper Furies, they were.

"The blow on the head?"

"Oh, that too could've killed him, no doubt, but that was done immediately after the poison was delivered, I think. It's a very fine window, I think, but someone's trying to jump through that window, I think. Perhaps it's just me."

"No, you will do for me. Time?"

"Well, there I can help you"

"Wait. His hand."

"What?"

"Look at the picture of his hand. I think he was holding something."

"So? Oh okay. I will check. You just might be right. God, do you have to be so smart at this hour?"

"I am awake, you see. Just had breakfast, in fact."

"For this, Dee, I will personally do an autopsy on you. Live. The trainees will learn a lot about how bodies behave from that, don't you think?"

"Can I make a request?"

"No, I will not put you under during the autopsy."

"Just send the film to the station, will you? I will sit with the PI myself."

"At this hour?"

"It's summer, it's morning, in an hour the sun will show his beaming face to the world."

"You go to hell. We've all been working for sixteen hours."

"Thanks, then, for sending the film. And you all sleep now. I will have something to go by for now."

He puts the phone down before she can say anything else.

⌘

He sits with the PI, to work away at various angles. He feeds the film to the PI, and then waits for a few minutes for the autodidactic neural networks to kick in. But he has a hunch that it's not going to be easy.

Eventually, the PI plays some music to tell him that it is now in a state of ready repose. From its generic analysis of the film, a must for all forensic crime scene examinations, the PI offers two options:

| Accidental Manslaughter | Premeditated Homicide |

He clicks on Accidental Manslaughter first, just to eliminate possibilities. The menu opens up:

Accidental Manslaughter
Sado/Masochism
Machine
Berserk Spouse

The list is long. This surely is not the road he wants to travel. He clicks on Premeditated Homicide.

Premeditated Homicide
Spouse>>
Love/Hate>>
Money>>
Insurance>>
Gang War>>
Tong>>
Triad>>
Local Mafia>>
International>>
Drugs>>

He doesn't know if it's any of these. He goes back, only to find a very small button, almost hidden away, which says,

Construct Your Own

"Ahh," he says aloud. "Using this is more difficult than solving the bloody crime itself."

"You are welcome to think that, Inspector," the machine says.

"Ah, I had forgotten you can talk."

"I am here to remind you. You forget every time, Dee."

"Don't you start calling me that."

"Sorry, Dee, the two handles are being treated as one. Your address is randomly chosen from these two. We've been through this, Inspector Dee. "

Thus, finally, he is getting somewhere. He talks to the machine for a long time, focusing on making it reconstruct the crime scene. The basic laws of physics, the machine says, given that we are not dealing with global spatio/temporal phenomena, should be applicable, considering the scenario chosen. It asks him to wait, and says,

"Would you like to watch the latest SQ Sajnovics movie while I prepare the visuals of the crime, Dee?"

"No, thanks, I have never seen any of hers, and don't want to."

"Some music, then? Hammer and Tongs? They are quite a rage."

The Inspector racks his brain. He remembers a name. He says, "Erich Satie, Gnosienne One."

"Sorry, Inspector, that's not included in this version. If you would like to upgrade, please click on upgrade."

"How long will that take?"

"Hmmm. Considering this is a government line, well, actually why do you ask? Get an Upgrade. Now."

"Cut your sales talk. Show me what you've got."

"Two brandies and one big—Chinese fried rice coming up, Dee."

To make it clear to the viewer that he or she is watching a computed reconstruction, the visuals are played backward. This is also meant to absolve the PI of any mistakes, in case some stupid Inspector takes it seriously, and finding it has made an error, files a case against the company. He is asked to choose the duration. He selects five seconds. He can always come back. He now remembers that one must go in very short bursts of time. Longer durations throw up more options. Hallo, dynamics, he thinks.

The dead man. There are several options given. He sees all of them. The first one shows the dead man rise straight up, with a few weird wiggles of his hips and his right palm jerking, and fill the frame with his dark grey coat.

He changes the camera angle. This takes longer. But now he is biting into it. From the lower right quadrant, with the first reconstruction as the reference point, the weird wiggle of the hips looks as if they have been pushed, perhaps by a knee or something like that, on the monkey bone. He gets tired after fifty angles. He changes the scenario. He splits the screen into two, one with the wooden slippers, the other with the flung away shoe.

He tries fifty angles on both the frames. He is by now exhausted. He gives himself a push that he pretends to be his last one.

The shoe rises from its position yet again, but this time it seems to strike something, and lands close to the slipper, the one standing on its side.

"Ahhgghghghg," he says. He has not said anything linguistic for seven hours.

He means, ah, there, there, there is something there. This shoe was thrown at somebody, hit that somebody, and bounced away to where it was found. So finally we have a precise location for the other person who was there in the room. The dead man threw his shoe at the other one, the shoe bounced off (Off what? Face? Shoulder, chest?) and fell where it was found.

He freezes the frame, and tells the machine to calculate all earlier freezes and map them onto this one, in a 2D representation of 3D substances and dynamics. He disables the Riemann function then and there. He didn't want further complications.

Now would a martial artist throw a shoe at an attacker? No. An artist? Quite likely. A monk? Equally likely. Only those who don't know how to fight throw things. People who know how to fight move their own bodies into a state of ready rage.

<p style="text-align:center">⌘</p>

Ching Hsu opened the door to this unfamiliar room, his shoes cramping his feet, and sat down on the bed. He was clutching the Golden Goddess as if it was his own body. Or a part of it. That was his mission. To bring the Golden Goddess back. With some relief, he bent down and took off one shoe.

He did not know that he was being used. He did not know that he had been chosen because he was dumb. He did not know that he was chosen because he would never be observed, never be thought suspicious. The School knew it. He did not know that the Golden Goddess could kill. All he knew was that his clothes, in spite of three months of practice and training, were uncomfortable. He wanted his robe, his wooden slippers, his cap of the White Lotus. Then he could sit down, meditate on Life and Death.

There is an insistent knock on the door.

The Inspector is still waiting for the PI to synthesize all the freezes he has chosen and show a continuous visual. He is thinking that the scenario that he has created might be a plausible one.

The Sub-Inspector knocks on the door and comes in. The Inspector turns back to the large touch screen.

"Sir, you need to know what has happened in the real world while you were here."

"So tell."

"The Chinese had hired a room in the basement too. We found seventeen largish boxes, all but one containing gold statuettes of what seems to be a goddess of some kind."

"Chinese?"

"Do the Chinese have gods and goddesses? I don't know, sir. We need a China expert."

"I know one. She will be available tomorrow, I think. So one is missing?"

"Yes. Also, we now have talked to the neighbours and others, sweepers, janitors, and so on, and there was a Chinese-looking visitor to that apartment. Nobody seems to have seen him go, but he seems to have gone."

"Description?"

"It's being fed into the ID Generator, but it seems to be having a problem."

"Why?"

"It's not able to make up it mind whether the ID is male or female."

"Who's running it?"

"You know who."

"Oh god. Just get her to generate a face, that's all we need. We are not going checking under people's clothes, now are we? Tell her that."

Both their phones rang at the same time.

The Inspector started talking to the Forensic Sensing Women, and the Sub-Inspector to another police station.

The FSW tell him that they have finally identified a tiny puncture, just under the nail, on the middle finger, which was the

entry point for the poison. As to the poison itself, it was some kind of fruit poison, certainly not local, quite possibly Chinese.

Another Sub-Inspector tells the Sub-Inspector that they have a homicide, a Chinese woman, found dead in a hotel room. Beside her, on the floor is a gold statuette of a goddess of some kind. There are no signs of violence of any kind.

They both look at each other, and put the calls on hold, and converse.

The Inspector tells the FSW that they must get to the second crime scene quickly, and tell him quickly if the Chinese woman is dead of the same poison that killed yesterday's Chinese man.

The Inspector tells the Sub-Inspector to take him to the Golden Goddesses.

They are all exactly the same: smiling face, large breasts, and large rounded tummies, sitting on their haunches. All are gold, it seems. All have come in identical packing cases. They have already been examined. They are all hollow inside. There is a small lever at the navel, which allows you to push open a small panel. The cavities are deep, almost three inches. One can only put two fingers inside. All had pieces of paper stuffed in the cavities.

One curious constable had put his fingers inside, groping and had got pricked by something, after which they put a small scope inside, to find that all of them had a very sharp needlepoint at the back of the cavity.

The Inspector is sure that he has already solved the case.

<p style="text-align:center">⌘</p>

Ching Hsu says,

"Come in." He thinks it is the janitor, wanting to fix the leaking tap in the bathroom. He sees a Chinese woman, obviously trained in martial arts, the way she stood still, or a monk herself, but he is very scared. He was not supposed to meet any Chinese at all.

"Where is it?" she says.

"What?"

She smiles and says,

"The parchment."

Ching Hsu feels as if an anaconda has just engulfed him in its coils, its tail finally coming round to start crushing him. He says,

"I don't know what you are saying."

"I do not wish to hurt you, Monk Hsu. But I have permission to do so, to retrieve the parchment. It is most precious to us. It was stolen from us. We shall have it back. It is unfortunate that you—"

Monk Hsu is grateful for the respect that she shows. He quickly opens the goddess's belly, puts his fingers inside—something pricks him there—pulls the parchment out with his two fingers, and puts it in his mouth. He bends down and throws his shoe at her.

She is already attacking him. He is biting into the parchment, his fear has dried his throat, but he feels it breaking up into little morsels. He is very determined. He stands still, eating the precious parchment. Now nobody will have it.

He picks up the goddess to hit her with it, but she is already hitting him in the chest with a foot, and he is falling backward, trying still to turn and make a run for the door. She plucks the goddess from his outstretched hand as he turns, and looks at it with fear and trembling. She has failed in her task. Hsu is running for the door. She throws the goddess at his head, and he falls down. She thinks he might be dead. She hits him in the same spot once again, making sure that he is. She does not know that the poison has already killed him in that one and a half minute. She puts the goddess in her bag, and saunters out as if nothing happened.

Outside the room, she finds nobody, and while going out of the building, she smiles inscrutably at the man standing near the door.

⌘

The Inspector calls up J, a friend of his, and asks her if her girlfriend, the China specialist has come back. She gives the phone number.

He calls her up, telling her the problem, and sends a picture of the Golden Goddess over the phone. She looks at it, and says,

"I am sorry, this is not Chinese at all. This is an Indian Hindu idol of a Yakshi. It looks ancient in design. But I don't know much about this. Why did you think I would?"

"Well, these idols are hollow, and some Chinese seem to have been murdered, these were found beside them. There must be a connection."

"Well, it seems to be rather obvious that they were carrying something inside the idols, rather than the idols themselves, surely?"

"I have thought of that, Professor. Thank you. Sorry to bother you with this."

He smiles bitterly. Academics, without exception, thought that he, as a policeperson, was stupid.

They go to the second crime scene, sirens, lights, in full display of their urgency.

The first thing he says, as he enters the room, where all the Forensic Sensing Women are still fussing and pottering about with their kits and cameras,

"I hope nobody has poked fingers into the Yakshi."

"The what?"

"This idol is an ancient Indian Hindu idol of a Yakshi. It is hollow, isn't it? Don't poke your fingers inside her tummy. There is a sharp point inside, which is poisonous. I don't think the tip can have enough poison to kill a third person, but we must be careful."

"How dare you solve the case before we have finished examination!" Almost all of them scream at him in unison. They almost stop working in protest. He tells them to carry on, he has only solved the murders, he does not yet know why. He realizes that the tattoo on the man's chest still needs explanation. He tells the Sub-Inspector to get the picture sent to his phone, and then calls the China expert, J's girlfriend, again.

"Sorry to bother you again, Professor, but I am sending a picture of the tattoo on the dead Chinese man's chest. Can you tell us what it means?"

She takes time.

"This is the mark of an ancient sect. Dating from just before the Ming dynasty. Hey, aren't you the one they call Judge Dee?"

He makes a grimace.

"You know what that means?"

"No, Professor. The one who started calling me that is dead, but she was not a China expert."

"Well, I am sure others know this, but Dee was a famous Judge in that period. I am not sure myself, perhaps it's the Ming dynasty. Eighth century. Solved every case. Judges also acted as investigators those days."

"The sect, ma'am?"

"White Lotus. Reputed collectors of ancient scripts, documents, medical formulae. Anything ancient was their interest. No martial arts. Scholars. Very peace-loving people. It's surprising that they are still around. Sad to know that one of them is dead. It would have been so instructive to meet him."

The Inspector sends her the picture of the tattoo on the back of the dead woman's hand.

"This is even more obscure. Let me look at my notes. I have the sect somewhere. This is so exciting!"

He asks the Forensic Sensing Women if there was any paper in the dead man's stomach. They get busy with their machines.

"Yes, here we are then. The Green Vine at Dusk. Mostly females. Martial arts, in various styles. Again, interested in ancient medicine. I think that could be it, Inspector. They might have found, or lost, some important formula. They would do anything to get it back."

The Forensic Sensing Women are cursing themselves for ignoring the paper. They had even joked about the Chinese eating rice in paper form. Yes, there was paper in the dead man's stomach when they analysed his food.

<p style="text-align:center">⌘</p>

Chen was crying bitterly. The monk had succeeded in destroying the parchment. She wanted to hunt down the Indian who had stolen the formula. No doubt he wanted to sell it to some pharmaceutical company. It was an ancient formula. She did not know what it cured. It was so ancient and secret that there were no copies, it was not even included in the list of formulae to be memorized.

In tears and hope, she wondered if the Monk in his hurry might have left some other piece of parchment in the ugly, bloodied idol. She opened it, and probed in the idol's hollow belly. She felt a pin prick on her finger and quickly withdrew it. There was a tiny dot of blood on the tip of her finger. Within two minutes, she was dead.

<p style="text-align:center">⌘</p>

The Inspector knows that though he has solved the case, that the man was killed by the poison, and by the Chinese woman, and that

the woman herself was killed by the poisoned tip in the idol's belly, he knows also that he will not be permitted to follow up, visit China, and get to know what happened really, what the formula was, who had stolen it. The police department did not investigate on speculation.

He will write up his report, and then, the case would be forgotten.

He does that, talks to his boss, who tells him not to speculate, think of the budget, congratulations anyway, and if you want we can send the report to Beijing, who might then investigate and get back to us.

He goes home, uneasy.

He shuts the door, and as he is taking off his trousers, a piece of paper rustles in a pocket. He takes it, stares at it uncomprehendingly. It's a receipt of some kind. He doesn't know what, so he reads it. It's the receipt the traffic police made out. But there is something wrong. The receipt is for five, and not fifty!

A flame of anger flares up in him. The chap has pocketed the forty-five, he thinks. He can always find out who it was. This petty corruption disturbs him even further.

He manages to watch only a little TV, and then as he is lying on the bed, he remembers the painting in the Chinese man's room. It projects itself onto his closed eyelids, and as he looks at it, a curious peace descends on him. Slowly, very slowly, as he stares at the picture, his pulse slows down; his mind settles down, his muscles relax. In five minutes, he falls asleep, with the picture printed on his consciousness.

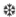

Girl with Matches

How old are you, they always asked, how old are you.

She was twelve years, eight months and twenty-seven days old. Her exceedingly beautiful, honey-coloured mum was exactly twenty-six years and five days older than her on that day, two years more than twice her age. Her dad, whom she had not seen for five years, was twenty-seven years, three months and twenty-five days older than her on that day. She did not have a brother or a sister. Her body weight was 30 kilos, which meant that she had about 330 grams of phosphorus, 780 grams of nitrogen, 6900 grams of carbon, 1,8300 grams of oxygen in her body, and that it was good that this phosphorus was not in its white form, otherwise everybody would be seeing her only as a flame, resulting in tetraphosphorus decaoxide; and that unlike the mature female body, the table of elements has only seven periods. She always announced these facts proudly whenever she was asked about herself, and she calculated these things properly and quickly.

Very few adults made much conversation with her after that. The answer usually had the effect she wanted.

She was not a very sociable child. When she enunciated these facts, she stared hard at the questioner, straight into the eyes, trying to frighten them into silence. Till now, except for her chemistry partner, she had frightened each and everybody who asked her such questions about herself. O_{10}, her chemistry partner, had fired her questions without listening to her answers, fiddling with the pipettes and jars, and her own notebook. O_{10} was plump, thirteen, already worldly wise because she had had her menses.

Her own name started with a P and had five letters in all, but she hated the number five, so she always called herself P_4. They didn't understand why. Most of them didn't know what they were supposed to have learnt in school. They were so dumb that they did not understand

that P_4 also meant P + four letters. Sometimes, she condescended, and wrote her name as P____. She had read on the notebook that many years ago, there used to be computers called P4, and the P4 computers were lords of that kingdom. She thought of them as regal, charming, dark-haired and handsome, but she didn't bother to find out more because finding out was so easy. One can find out anything about the past on a notebook.

She had taken a long time to learn the notebook. Her mum had got worried. Learning the notebook was the most basic of education, and she was not doing very well at that. Mum stopped worrying about it when P_4 showed her a picture of her own on the notebook—mum there on the notebook, so different, and mum, the same as she knew her with her arms around, kissing the top of her head because finally she had managed to touch the right parts of the screen, and found what she wanted. Mum's hair falling around her cheeks was such a pleasant feeling. She had decided at that moment that she would use the notebook more, so that mum would hug and kiss, and hold her in her arms, and the hair would fall around her cheeks.

She knew then, already, that she was a problem. She knew that often she did not remember to wash herself after going to the loo. The sound and sight of water washing away her poo was so attractive that she flushed before she had washed or wiped herself (depending on what kind of loo was available for her poo). She knew that she looked like her father, who was thin, bespectacled, moustachioed, and short. That merely meant shorter than mum, who was very tall. That was the first thing O_{10} had said to her when they were made partners in studying the table of elements.

"Your mum is tall, your father short."

"How did you know?"

"What?"

"How did you know that?"

"You mean they really are?" Then O_{10} had burst out laughing, explaining that this is what she said to everybody when she was made to study alongside someone.

She called the table of elements Chemistry because the notebook had told her that many years ago, the carbon hexagon she was looking

at for fun, belonged to chemistry and she could quote, "there was a time when knowledge was divided into *disciplines* like chemistry, physics, biology and words like that, and the table of elements was thought to belong to the domain of chemistry".

The lanky teacher had scolded her for shooting her mouth when she had said that this was chemistry and had come to take a look at her notebook. This was one of the many insults that P_4 had had to face for being intelligent.

<div align="center">⌘</div>

"I am sorry, but it does *look* as if she has Asperger's, but she doesn't."

"What do you mean?" her mum said tonelessly, she was sure that her child had Asperger's Syndrome. That would explain many things that the child did.

"She is not excessively obsessive about things, you see, so that has to be ruled out."

They talked about her as if she wasn't present. But she understood everything they were saying to each other. That was about less than a year ago. She had difficulty in calculating the distance. The past was, she thought, not a measurable, Euclidean space. She had quickly focused on what the consultant was saying.

"It is *not* that she has Asperger's Syndrome. It is that she is just a, shall we say, unsociable child? She will be brilliant in some areas, and dull in others. *That* does *not* mean that she is *exceptional* in *that* sense."

Her mum was angry, and said,

"Your *italics* are *not* funny."

But P_4 was not looking at the text transcript of what the man was saying, she was looking at the face, and the face was exceedingly funny. The consultant's left nostril had a hair sticking out, but everything about the rest of his facial—labial?—yes, labial hair was prim and proper.

P_4 thought to herself, why isn't there a way of talking to people without getting so close that they look ugly? It was like the sex stuff they taught in school. The making out was nowhere as exciting as some of the stuff she had seen on the notebook. She had laughed out aloud.

The consultant was annoyed, and he only said,

"This is all I can offer. Thank you," before he terminated the connection.

She went out of the room before mum could look at her accusingly, as if it was all her fault, when the truth of the matter was that the consultant was right. She wished mum could accept that fact, without making her into some kind of exceptional person with some Syndrome. She knew about Asperger's because she had asked the notebook to tell her about it. It was only discovered in people some hundred odd years ago. It was not absolutely necessary that people who had Asperger's were exceptionally intelligent in some other areas, but that they were basically a-social, liked certain things intensely, disliked certain things intensely, tended to be dirty, but were often good at abstractions, music, mathematics, crossword puzzles, etc. It was mostly discovered in children and adolescents. She had shown her notebook to O_{10} in the bus, huddled at the back, and asked if she had Asperger's.

O_{10} sucked her cheeks in and went into deep thought, her eyes rolling up and closing. After a minute she looked at P_4 and said,

"You are nothing more than a dirty stupid cow. Asparagus indeed. You want be the heroine of asparagus or what?"

Then they both burst into laughter, nudging and elbowing each other, calling each other all the names of vegetables that they knew. They were still giggling when the teacher came into class. P_4 listened solemnly to the teacher for some time, and then drew a picture of spindly asparagus, and drew eyes on it, and gave it hair like the teacher's and sent it to O_{10}, and then they were both giggling again and the teacher went up to O_{10} and looked at her notebook, but there was only the ellipsoid shape that she was displaying on the screen, repeated exactly on the notebook. By then others were looking away from their notebooks at the teacher, and the teacher did not want to distract others, and so she went back to the screen and started talking equations again. O_{10} dropped her handkerchief and bent down, and stayed down for a moment to get the giggles out of her mouth. P_4 had no such need. She was in control of her giggles.

⌘

Two days after the giggling incident, the bus was stopped by the police just before the N-BAR, for a long time, because there had been an accident with an automated car. O_{10} had been quiet, so there was no conversation. She looked at O_{10}, whose eyes were red, and she seemed to have been crying. P_4 asked her,

"What's wrong with you? Why've you been crying?"

"It's nothing."

"You want to be the heroine of nothing or what?"

O_{10} tried to smile, but there were tears in her eyes. Before she could say anything, the bus-driver told them that they won't be going to school, that he was taking them home because the N-BAR was going to take a long time to clear, and of course in this stupid City there was no other way across. He mumbled something about a man being burnt. O_{10}'s home was close to the N-BAR, and she seemed particularly unhappy at the prospect of going back home. She called her folks and told them that she was coming home, that school was cancelled for today.

P_4 did not have to do that, because there would be no one home, and she had the key. She knew that she should be letting her mum know what had happened, but she didn't. Mum was too busy, and she was only going home. She admitted to herself that it would be a pleasure to be at home, with unsupervised access to the main computer. She was going to try some ideas she had had while drawing the asparagus teacher that day.

She was occupied with those ideas when O_{10} got off the bus and mouthed words across the window, solemnly,

"Bye, see you tomorrow."

She waved to O_{10} as the bus started moving. She saw her standing there, not wanting to go home, looking at the bus.

⌘

She pushed the key into the slot and punched the numbers, and opened the door, and halted to take her heavy notebook off her shoulders.

The smell! Perfume? Yes. Male. She didn't know how she knew, but she knew that it was not a perfume that her mum would wear, or any other woman she knew. Very strong. Whoever it was must have

stood at the door for a while. Just to be sure, she checked the alarm panel beside her, but everything seemed fine, nobody had entered the house by force.

Cautiously, she closed the door behind her, and stood scrutinizing the house meticulously. A man had been here. She must be careful. She moved inside slowly, her heart thudding, she could almost hear it beating in fear but strongly. She began to notice things that she had never noticed earlier. A cushion on the sofa was disturbed, which is to say it was not where it was when she left in the morning. The telephone screen was at an unfamiliar angle, she had to pull it down a bit to be able to look at it comfortably.

She kept jerking her head to see if there was somebody behind her, but her instinct told her that she was alone. Whoever the man was, he had left, and stood in the door.

She moved to the kitchen. Nothing wrong there. Everything in its place. Nothing wrong at all. She scanned more carefully. The coffee mugs! She always put them with their handles on the right. She had scolded her mum so many times for not putting them down as she wanted. It was easier to pick them up if the handles were on the right, all of them snuggling each other like that. She *had* put them there like that after breakfast. Her mum must have had some coffee after she left. But then, two?

She began to sweat, her spine curling up like a cat about to spring, she shivered, and there were goosepimples on her arms and legs. Mum had had coffee with someone. Presumably, the man who had come in. She checked the time, it was only ten. Mum must've left ten minutes ago or so. With the man. Relief was mixed with anger and anxiety in a way she had never experienced earlier. A man had come to meet mum.

She was being unreasonable. Must be a colleague who rode with her to office. But anger began to burn in her mind like a white cool flame that gave no heat. It was unbearable, the idea. She might start screaming. She had to keep calm. She was determined that she would not behave like a child anymore.

To calm herself, she methodically did what she had been forbidden to do when alone. She went to the kitchen, and took the large metal bowl that she had got from the street one day. It probably was a metal hub cap from some car. Then she bent down, opened the

shelf and reached for the matches. She could not find them. She sat down and peered into the shelf. Could mum have hidden them away? No, she couldn't, surely. She moved the spare cups and dishes, and found them, yes, mum had tried to hide them. Not very hard, though. She felt strange, mum was hiding things from her?

· She took the matches, the metal bowl and went to her room. She set the bowl down, and looked for old newspapers, glossy magazines, and took some of them and tore them up into the bowl. She went back to the kitchen and soaked a towel in water as a precaution and took a glassful of grape juice from the fridge, and with the towel went back to her room, and sat down beside the bowl. From under the bed she took a small piece of candle, and broke it into several flakes, showering them on the paper. With a sense of calm descending upon her, she struck a match and looked at it intensely as it burned, and then, just before it burnt itself out, put it beside a piece of paper, into the metal bowl. The paper caught fire, flames burning blue at the bottom, yellow at the top and wonderful red in the middle, the wax melted slowly and slowed down the burning, steadying it in a few places to yellow. She stared into the flames, and thought of fire-eating. She had always wanted to be a fire-eater, from the moment she had seen a video on the schoolroom screen. The history teacher was describing the strange ways of the people of the past, the hazards, the dangers, the lack of security in public places; but all that P_4 saw was the thrill of fire exploding from her own mouth. Dragons, she thought, these people must be descendents of dragons. She couldn't become a dragon, she knew. Dragons didn't exist. But she could become a fire-eater. She could do it. The kerosene, or petrol must be ejaculated with great force, and then the fire would only go away from her, not into her mouth.

Except that when she forced her mum to go with her to buy kerosene, or petrol, the woman at the counter did not know what she was talking about. Her mum had indulged her, and very subtly, humoured her, and even more subtly, told her that she was stupid. She breathed the fumes in, smelling paper and wax and feeling heat. She exhaled fire from her mouth, "Whoooooosh...!"

She was calm by the time the fire was reduced to ashes. She put everything back. As she came out of the kitchen, mum called.

"Hallo, mum."

"Where *are* you?"

"Home."

"Good. I just got to know that something happened at the N-BAR, and—"

"I am fine, mum. I am fine. We had to turn back at the N-BAR."

"Why didn't you call me?"

"Oh, I don't know, I thought you might be busy."

"You know that you—are you smiling, darling?"

"No."

"You should call when something like this happens, you know. You know I worry so much about you."

"I really thought you might be busy."

"So what time did you get back?"

"Um—I think about ten-thirty."

That was an odd question.

"When did you leave, mum?"

"What?"

"When did *you* leave?"

"Nine-thirty, as usual. Why?"

"Just asking. Wondered if we might have just missed each other."

A very brief silence. Had she given away too much?

"Did you eat something?"

"I will now."

"Good. There is—"

"Grape juice in the fridge. I've already had some."

"Study for some time, and watch TV. I should be there in an hour or two. The case just got postponed yet again."

"Happy lawyering, mum."

"Hmmm. Bye, then."

"Bye, bye, bye."

<div align="center">⌘</div>

Feeling insecure again, she went to the house computer, and logged in, and sat watching the only video that she had of her father. It was a five-second clip she had accidentally found on the machine and promptly hidden away. She was just a baby in the video, in dad's

arms, and he was swinging her, saying something or the other. There was no soundtrack. She was sure mum had shot that clip, not knowing how to work the camera, how to get a good image and sound. She played it again, this time putting it into a repeat five times loop.

She felt a little better, but she opened a geometry file and displayed ellipsoid shapes on it, and went to her room. From her cupboard she took a more recent picture, taken just a few months before dad had gone away, and mum and she had moved into this house. By the time she was ten, she wanted to meet dad, and had located his phone number after a cursory search via her notebook.

"Why did you not speak to me, dad?" she said to the photograph. But she knew the answer, it was clear to her after three more attempts on the phone, and ten mails to which he had not replied. He had just disconnected after she told him who she was, on the phone. That evening she threw a fit, insisting on getting a new phone for herself. For once, mum seemed to understand the intensity and heat, and had given her own phone to her, a new one.

She got up and hid the photograph quickly. Mum was already coming in.

"You haven't eaten yet?"

"No, I had to go to the loo."

"I hope you remembered to wash yourself." Mum was smiling.

Responding in mock anger, she said,

"Mum! I am not a child anymore!"

She didn't want mum to go into the kitchen as yet. She said,

"You go and change or something, I will get the food."

"No, I don't need to change."

Mum went into the kitchen, and came out with a frown.

"So what's that smell?"

"Sorry, mum. I am sorry. I burnt some paper to look at the flames."

"I told you—"

"It's alright, mum. I know what I am doing."

But mum was worried, and they ate in silence. She saw mum look at her watch, and her hand moving as if to pick up the phone from beside her, but she didn't.

⌘

The next day, P_4 had a plan ready. Next time mum looked at a watch and reached for the phone, she will stick around and see what happens. Much better if mum couldn't find her phone and had to use the phone on the computer. There would be P_4 sitting at the computer, studying hard, and there would be mum, not being able to call.

She would also check the numbers on mum's phone, she decided.

She had to wait for three days, each day making her wonder if mum had caught on, if she had already figured out. Each moment in the house an anxious moment. She did not even notice that O_{10} still looked totally dark, and that she was limping. Mum was very smart. She was the best copyright lawyer in the City, if not beyond.

When mum went for her bath, she went into her room, and took the phone and put it under the file on the work table. Then she went out, hoping vehemently that the phone itself won't ring. She logged in to the main machine, and started doing her homework.

When mum came out, she was truly engrossed in it.

"Have you seen my phone?"

Staring hard at the screen, knowing that mum couldn't see her face, she said, grinning to herself, but keeping the grin out of her voice, she said,

"No, why? Why should I know where your phone is?"

"Shut up. I need to call a client."

If mum was right, then she was doing something wrong. She was a little worried. But she went on to compose her face and look at mum.

No. Mum was lying. That was not the bored look she had when she called her client, which she did very rarely anyway. Mostly clients called her in desperation. And mum's eyes were looking brighter. Her mouth was open. Mum was *lying. To her.*

"Why don't you just look for the phone?"

"I can't find it!"

"Check your bag. Your jacket. Your bed. Your table. How should I—"

"Shut up."

"Mum!"

"Oh fuck," mum said, "I don't need this," and went back to her room.

Tears forming in her eyes, P_4 lost all interest in her homework, which she was just getting right. Geometry was so difficult, and then mum had to—had to—as she wiped her tears, she heard mum's phone ring. Mum had left the door open, and she heard mum *giggle*.

P_4 sat looking at the screen blankly, trying hard to sense what mum was saying on the phone, but she could hear only the higher decibels. Almost unknowingly, she got up, and found herself walking to mum's room. She didn't care if mum found out that she was listening like that. She didn't care. She *had* to know.

"No, smartypants, I didn't for*get*. I couldn't find the fucking *phone*, you know."

Giggle.

Giggle.

Giggle.

"No, I gotta be bloody care*ful*."

Mum was speaking slang.

"Um hum, lesseeeee. Yes. Next Thursday should be possible."

"Yes. A few hours, I guess."

"No, I am not sobbing."

Mum was crying? She wanted to see mum, but she didn't have the courage. She already had heard enough, and before she was caught, she must rush away, and *not* make a *sound*.

Slowly, deliberately, silently, she went back to the machine and punching away the screensaver stared at the ellipsoid shapes again, trying to figure out what they meant, and why she was supposed to know what they meant.

She would need to be very careful. She must compose herself, and have a conversation—about something else—with mum, she must not sit there glum.

When mum came out, she was looking happy. There was a flare of anger, but she quickly stilled it, and said,

"Mum, help with these ellipsoids."

"Unmnmn?"

"I don't know what they mean."

"God, bebbe, neither do I, you know."

"I want to sleep."

"Eat first."

"No."

"What's on the TV, eh, bebby?"

"I want to know what these mean, but I am hungry and sleepy at the same time. And no, I am not making excuses to watch stupid TV."

"Alright, forget the geometry. Eat. Then you go to sleep."

Mum kissed her, and she felt happy, but by the time mum closed the door and went out of her room, she was already anxious and frowning, and plotting the next moves, the next steps in the investigation, which would be more difficult, she knew, because she would have to follow mum next Thursday, and take a look at the man she was talking to in that manner, giggling like a schoolgirl. How disgusting.

Would mum be calling the man again, now that she was supposed to be sleeping? How could she find out, without following mum, which would be so difficult? Was she talking to *him* now?

She didn't have the courage or strength to get up and see if mum was talking on the phone again. She lay there, anxious, worried, unable to sleep.

⌘

The next day, O_{10} had a *bandage* on her forehead, and she was limping. P_4 cursed herself for being self-centred, and not paying attention to her. She hugged O_{10} and there were tears in their eyes.

She whispered,

"What happened?"

O_{10} whispered in her ears, as they hugged each other in a fierce, ferocious friendship,

"Dad's done something wrong. Don't know what. Mum's upset. So she beat *me* up."

P_4 could not stop crying, but her eyes were dry. They were almost at their seat in the bus. She whispered, as they sat down,

"Why?"

"Mum doesn't need a reason for this."

"Does it hurt still?"

"It did last night. Mum's drinking way too much. I was feeling very bad and wanted to sleep beside her, and then—"

"Shhhh, shhhh."

"I had a bad time too."

"You weren't beaten up by your mum, though."

It was her turn to sob.

They got through school somehow, this time sitting beside each other, holding hands, hiding their pain under their desks.

While returning, they plotted to get to the root of their problems. P_4 pointed out that they could not go about crying like babies. They had to do something.

In a week's time, O_{10} had figured out that her mum was upset because her dad was having a relationship. She listened to conversations behind doors, kept a watch on what time dad came and went, and how her mother reacted to him and to her as well. It was clear that her mother started to drink at lunch time, and by the time O_{10} reached home, she was ready with anger, blame, plain viciousness. O_{10} wanted her dad to do something about the drinking, but he seemed to have given up. There was nothing to be done, but get through the evening somehow, until dad returned, after which the whole scene shifted to him, and quickly worsened. If he had the energy, dad would come and speak to her, sometimes hug her, and put her to sleep, saying again and again and again,

"It's okay, darling, it's okay, things will be alright, things will be alright."

In the same week, P_4 observed her mother with some detachment. It was easy, because it was clear that mum was changing, and feeling happy and worried at the same time. A very strong anger was forming. She could see it coming. She decided to keep away from mum. This anger was not going to go away with paper-fire. It was going to need something stronger. She began to think of a stronger fire.

Cooking gas. Too easy. No skill. Bed sheets, the same. Not many other inflammable things. Electricity wiring was hidden behind layers of panelling and cement. Everything, almost, was insulated from fire. The aerosol can. Hmm. That had possibilities. Hold a flame and press. Almost like fire-eaters. She took a towel, and held it under water for several minutes, and covered her chest with it. She took another towel and soaked it in water the same way. Then she gripped the can tightly covering her hand and the can with the towel. She had to try several times to light the matchstick with one hand. She lit one finally, and held it away from her, and pressed the can. But the spray

put out the match instead. She needed a lighter. She would have to buy one.

She managed to buy the lighter two days later. Her anger had reached a fine steady flame by now. Mum had lied to her. Perhaps she had lied about other things as well. She asked a number of times,

"What's wrong with you?"

P_4 was sure that the question was merely meant to distract her. It was not meant at all.

But one night mum came into her room, without knocking, and she was playing with her lighter, the aerosol can close by. Mum looked at her, and came and sat down on her bed.

"What's wrong with you, darling?"

"Nothing, mum," she said, and looked away.

"You are playing with fire again. And you've not been eating properly, and you haven't as much as smiled at me."

"I am fine, mum."

"Got yourself a boyfriend, who then ditched you or something? You behave very much as if you were trying hard to fall out of love. Tell me, you can tell me anything."

P_4 was sure that mum didn't want to hear what she really might have to say.

But then, unexpectedly, mum bent down and hugged her, and kissed her on the cheek, and said,

"Alright, alright, you don't *have* to tell me. But make sure you have a smile for me tomorrow, or perhaps the day after? Promise?"

She could only stare at mum, she already felt like smiling. But she didn't. She still had a few things to do.

"Good night, darling," mum said, and went out.

She put away the lighter, pulled the blanket over her head, and curled herself to sleep, weeping silently.

<p align="center">⌘</p>

The next day, O_{10} told her, in the bus,

"Mum's gone away."

"What?"

"Yes. Packed her bags, took her jewellery and went away."

"How—"

"Last afternoon, I went home, found this note. Called dad. Note was for him. Not for me. Dad said mum said to tell me she was sorry."

"Why didn't you call me?"

"What would you do? But yes, why haven't we called each other on the phone ever?"

"Yes, why?"

"And now I am determined to find out if dad's really having an affair. No, I won't ask him. I couldn't."

"Then how are you going to find out?"

O_{10} looked at her strangely.

"I guess I have to follow him."

"But you can't! He will know you from thirteen miles away."

"I know. I could disguise myself. Take some clothes from you or something. Put on a hat or something."

"That's crazy. No, this needs some thinking."

P_4's mind was ticking away.

"He doesn't know me, now, does he?"

"What? No."

They both said, in unison,

"We could—yes."

"And we could synchronize using—"

They reached for their phones.

"Yes, that's true. Why haven't we called each other ever?"

They sat down and plotted. O_{10} was feeling much better, she could tell. Then she said,

"O_{10}, will you follow my mum?"

"What?"

"No, I—just want to be sure that she goes to her office or something."

"Why?"

P_4 looked at her sternly, still hiding the confusion in her mind, not telling her.

"Just do it, okay?"

"Sure I will do it, but—"

"Come on."

"Okay, okay."

When mum came in, P_4 told her about O_{10} and how she had become friends with her. She didn't tell about following O_{10}'s dad, or her mother leaving. She was merely setting up a context for what they were to do.

Her mind was calm, now that she was doing something about her own confusion, and helping out O_{10} with hers. But she carried the aerosol can in her bag.

Then she called up O_{10} to find out what was happening. They talked chemistry-code, so nobody could follow what they were saying to each other, litmus paper, oxidization, combustion, mixtures, periodic tables.

Mum was in the kitchen, and P_4 on the sofa, and mum looked at her and smiled.

They didn't take the risk of going over to each other's places. They couldn't afford to be seen by their quarries. Thursday was a holiday. For everybody. How was she supposed to follow O_{10}'s dad? He may just sit at home.

On Tuesday, P_4 told mum that Thursday was a holiday, and that she was planning to go to O_{10}'s place for some study and some fun.

Mum didn't make a fuss at all. In fact, she smiled, and P_4, feeling evil, thought, it's not for my fun that you are smiling. She stilled her mind with a tight mental slap to herself.

"What's wrong, baby? What was that?"

"What?

"You frowned very hard, darling, what's wrong?"

"Oh, nothing, I just remembered that I should take some more money with me, you know, to take flowers or something?"

"What? Hey, that's so sweet of you, baby."

Mum was glad that she was showing some positive social instincts, finally. Finally she was growing up, stopping being grumpy and rude most of the time, perhaps. P_4 kept smiling, while half smiling, half crying inside.

"Sure, baby. But how long do you plan to *be there*?"

"Well, I don't know. Maybe I will go there, say, around nine-thirty, and be back by evening or something? Why?"

"Well, I thought maybe, I will work in the office for some time, and I was thinking let's go out for lunch, you know, have some time away from this boring house or something, you know? But hey, that's okay, we will go out for dinner. Maybe a film in a hall or something?"

Does she mean it, really, or is that some more lollipop to keep me drugged and unknowing? She knew that people in the past drugged their children so they would sleep most of the time, while adults worked in the fields. But no, mum seemed genuinely happy. She hated hating mum. But it resurfaced every time she remembered the phone incident. She hated being confused. She wanted to come clean and ask mum straight what was up, was she like, *seeing* somebody? But she knew that she would never be able to say it the way it should be said, nice, curious, simple, her lips would curl without her wanting them to, her eyebrows would fold up and leave their place, and god knows, after that mum would get into her stop-being-anti-social routine, and how she was thinking of dad, and that would *be* that.

"So I will check tomorrow what movies are showing at Star, and *no*, mum, I *get* to pick the movie, okay? You are working for some time at least, this *holiday* is mine. That's the sum."

Mum smiled, and P_4 felt like a worm.

In her bed, under the thick winter blanket, she wept herself to sleep, but the tears did not douse the flame of anger.

⌘

Wednesday didn't happen.

⌘

Thursday, she woke up reeling from strain on the previous evening , and the late night call from O_{10}, telling her that no, her dad was *not* staying put in the house, tomorrow, that *is* today, but had told her she was more than welcome to have the house for herself the whole day, and get her friend over, and why just one, in fact, he had asked.

She rushed through her toothbrush, her poo, her bath, her dress. Oh fuck, my brains, and O_{10}'s too, she said under her breath, as she pulled up her pants on her bum, bending, her back complaining of the restless sleepy night. O_{10}'s phone had a picture of them together, what if her dad has seen it, recognizes me?

"Coffee's read*ddiiie*," mum screamed from the kitchen.

She breathed hard, and the water trickling down from her hair went into that breath and she choked, coughed, and woke up, thank god. Time to act, idiot, she told herself.

<p style="text-align:center">⌘</p>

She ate her breakfast quickly, looked at mum who seemed totally relaxed, and worried about O_{10}—what if mum didn't go anywhere? What would O_{10} *do*?

"Remember to buy flowers," mum said as she left, and mum gave her lots of money, just in case you feel like getting something else too, mum said.

She met O_{10} halfway as decided; she was almost getting late.

O_{10} was looking unsure, as if now she was not sure she wanted to *spy* on her dad or something, but she had already committed herself, and P_4 assured her that no, they were not *spying*, they were finding *out*, that was the sum, and there was nothing wrong in finding out. Then she told O_{10} where to stand so that she is not seen, and how she should in fact take out a book, and sit down beside the hedge, there is a nice comfortable place there, you can't be seen by the front camera, or the street camera, and there is no wind even, but you can still see people coming in and going out. Did she have enough money, because mum was sure to go to office in her car, and she would have to follow, when she did. Then they were done, and P_4 was on her way to O_{10}'s place, and her dad. She made sure yet again that she had his picture on her phone. But O_{10} had shown her so many pictures of him that she wouldn't miss him even if he disguised himself, she thought. O_{10} doted on her dad more than she herself doted on her mum.

She was worried that he might leave the house or something before she took her position across the street. O_{10} had told her that there was a small park there, and she could sit on a bench and pretend to read, and still watch the house. They did not live in an apartment, they had a house for themselves, a large one.

It was a very pretty house, with a small garden around it, and a car was parked there, a large white car, and even from this distance she could see the fluffy rabbit that O_{10} had put there just to make sure that

P_4 didn't miss it, and that meant O_{10}'s dad had not left yet. She sat down on the bench, took out a book, and sat reading, the sun warming her back.

She felt very strangely peaceful, though her mind was going in circles in what seemed to be an infinite loop. What if mum doesn't go out, what if O_{10} misses her, what if when mum leaves and O_{10} couldn't find a taxi, what if, what if, what if, what if.

She saw movement in the corner of her eyes, and turned to see a boy riding hard on a bicycle, yellow, muscular, going quite fast, and a very large fat man walking by her bench. She felt vulnerable suddenly, because the man stared at her very hard, and he had a bad stare. She gripped her phone.

It rang a few minutes later, and O_{10} said,

"Hydrogen."

O_{10} was in position.

"Helium," she responded. Now they just have to wait.

For a brief moment, she didn't know why she was doing this. She closed her eyes for a minute and focused on the house. A window closed. She was scared. Another window closed. He would come out in a minute! She got up and crossed the street. O_{10}'s dad came out, and went to the car. She turned back a little and looked for a taxi. There was no taxi in sight. He got into the car. The whole plan was falling to pieces. She didn't know what to do. What would she say to the Taxi-Driver? Follow that car? Would he do it? Or would he only see a crazy kid, and ask her where her dad was, or her mum?

O_{10}'s dad was trying to start the car, but it had not started. He got out of the car, looked at his watch, and then pulled out his phone. She went closer, taking her phone out herself, and stood close to him, pretending to be engrossed in speaking on the phone. He said into the phone,

"No, take your time, I am getting a little late myself, the bloody car has refused to start. Why do such things happen to me?"

Then he smiled, and started looking for a taxi. There was no taxi on the road, so he started walking away from her. She continued to speak on the phone, and followed him. He was quite tall. Well dressed, and he looked very strong. He was walking fast, and she had to walk really fast to keep just a little behind.

At the taxi stand, he told the Taxi-Driver to take him to the Triangular Park, C Corner. She was almost beside him, walking past, when he said that. She walked a little further, and then stopped, seemed to change her mind.

She called O_{10}, who had managed to stay where she was. Her mum was still inside the apartment, unless she had gone out some other way, which there wasn't. Then O_{10} gulped and said,

"Wait! There's a car going out—"

"Deep Sea Green. Small."

"Yes."

"She's must be going to the office."

"I can't see any taxi!"

"If you don't find any, it's okay. Then you come here."

"Where? Your dad's just got into a taxi and has gone to Triangular Park, C Corner. I am going there now. Call me when you are close, and I will tell you where not to come."

"Okay."

P_4 got into a taxi.

As she closed the door, the driver said,

"You have enough money with you, child?"

"Hm."

She was so annoyed, she wanted to try the aerosol/lighter trick there and then on his face.

"Triangular Park, C Corner."

She called O_{10} and said,

"Lithium."

"Beryllium. I still haven't got a taxi."

"You walk on the left, at the third corner there's a stand."

It took ten minutes to reach C Corner. She paid the Taxi-Driver and got off, wondering if O_{10}'s dad might just have gone away, or gone to some house or something across the park, there was no need to believe that he had come into the park. She had been smart in knowing where he was taking the taxi, but that might mean nothing.

She walked into the park, as if she was there for a brisk walk. Not here. Not here either. The roses, they were blooming. Beautiful, slightly yellowish, light streaming through the branches. Some of the trees were immense. There were a lot of people around. That was good.

Ah. There he was. Sitting elegantly in his casual almost sporty clothes. The light did something nice to his face. She sauntered on, passed by him; he was sitting on a bench and reading a newspaper. He must've bought it on the way. He looked as if he had come to be alone, peaceful.

She found herself a bench crosswise, a little behind him, so that she could see him at about a seventy-degree angle. Just as she thought that his nose was more hooked than it should have been, he looked at his watch.

She called O_{10} and said,

"Boron."

"Carbon! He is there?"

"Yes. Sitting down, reading a newspaper. Looking at his watch."

O_{10} seemed to take a deep breath. P_4 knew what she was feeling. She only hoped that O_{10} didn't want an immediate confrontation with her dad. She should do it at home.

"Nitrogen! Getting into a taxi."

"Oxygen. Good. It will take you about ten minutes."

"But how—"

"No, don't worry. I have got all angles covered. He is sitting on a bench facing the C Corner, so if you come in from B, he won't be able to see you. And when you come in, get behind the hedge, walk on the lawn, in case he looks back for some reason. And almost the first thing you will see is me sitting here. You tie your hair up, god, we should've exchanged clothes, as we thought earlier. Then from a distance you could've managed even if he saw you. Clothes matter in this kind of thing."

"Alright. Fluorine, then."

"Neon."

A change in the sequence, they had decided, meant trouble. There was none. She hoped there would be none. They might get through the whole table if there was, and if this lasted very long. If, for example, O_{10} got stuck in a traffic jam or had to change taxis. Or got lost anyway in the park.

She waited patiently. It was so still and peaceful that she could fall asleep, she thought. Nothing is going to happen for hours.

She saw a man approach, smiling, and he sat down on the edge of her bench. She disliked his smile, rummaged in her bag, took out a

book, and without letting him see, the can of aerosol, and the lighter. She looked down at her book and once in a while made sure that O_{10}'s dad was still sitting there. He was totally engrossed in the newspaper. She wondered if this man bothered her she could run up to him and ask his help. The man on her bench said,

"So what's it you're reading, kid?"

She didn't even look at him.

A few minutes passed.

The man put his hand on her shoulder, and said,

"Nice shirt you're wearing, girl."

She picked up the can, transferred it to her left hand, and pointed it at him, and with her right, she clicked the lighter on. A blue flame emerged. She said,

"I'll burn your face if you touch me again. You want to try?"

More than the can, it was the flame, and the ferocity evident on her face that made the man back out, silently, and go away. Slime of the City, she thought. She felt tremendous after having threatened the man. But he might come back, she thought, so she got up, and put her book in her bag, the lighter in her pocket, and kept the can in her left.

O_{10} called.

"Sodium."

"Sodium." P_4 said.

"I am stuck in a small traffic jam. But the police are here and it's already clearing. Five more minutes. But what? You said Sodium."

"Yes, I've had to leave the bench. Some horrid guy sat there, wanted to touch me. I almost burnt his face, you know. The aerosol trick. It worked."

"Don't try it for real, idiot. You'll only burn your fingers."

"No, I've figured out a way."

"I don't want to know. If you ever try it, you'll burn your fingers. That's what you need to know."

"I said don't worry. I know what I am doing. My grandfather to the power of ten was a fire-eater."

"Yes. Sure."

"So where are you now?"

"I am going to go, and sit myself down on the lawn behind his bench, hidden by the hedge, and a tree."

"Be careful, he's very smart. God, I hate him."

"No, don't say that yet. We don't know yet."

She wondered where mum was.

"Okay, moving now."

"Okay, five more minutes, I guess."

"Magnesium."

"Aluminium. See you soon."

She sat down on the cool lawn, making sure O_{10}'s dad couldn't see her, not with a casual look back. He would have to stand, then he would see her.

She waited.

It took six minutes and seventeen seconds. Her phone rang, O_{10} said,

"Silicon."

Finally, she thought, and said,

"Phosphorus."

She had been sitting with her back to O_{10}'s dad. She looked back at him, he had put the paper down, and was staring straight ahead.

She turned back, and saw O_{10} make careful progress across the hedge, disappearing occasionally. Then she was fully visible, and she was staring at her dad. She tip-toed up to where P_4 was sitting and said,

"Shit. It's true. He's meeting someone. And the bitch is really beautiful."

"What?"

"Shh."

P_4 turned and looked at her friend's dad, colour drained from her face.

Shit. She thought. Mum has found out what I am doing. But no, how? What? Mum? What was mum doing here?

She held hard onto O_{10}'s arm, almost hurting her. She sat down hard.

"What?"

"Shh. Mum's found out what we are doing."

"Mum? Whose mum."

"That's my mum?"

She was crying. She was scared. Everything had gone horribly wrong. She couldn't bear to turn and look. O_{10} was staring hard, though, and there was a weird smile on her face.

"It's not what you think, idiot. My dad and your mum are holding hands."

"Wha—"

O_{10} giggled. Her face was red with a strange excitement. She bent down and whispered in P_4's ears,

"Do you think they will kiss?"

A wild joy filled their hearts. Both turned and nudged each other and tried hard to control their giggles. They felt like dancing. Then they said to each other,

"Let's scare the hell out of them."

Lithe, and light, they slid over the hedge, and bent right behind the bench.

O_{10}'s dad said,

"Traffic's really become bad. I was getting worried."

"What's your daughter doing then?"

"She's having some friends over. Practically told me to get out of the house, last night."

"Mmmm. So we have some time."

She rested her head on his shoulder.

That's when the two said, loudly,

"Boo!"

It was O_{10}'s dad who yelped, P_4's mum just jumped a bit, and was ready to face whatever there was behind her, her fingers already groping inside her bag. But then the two had twirled and danced around the bench, and were dancing, and giggling, holding each other and doing a circle, screaming in delight,

"We did it! We did it! We caught them! We caught them!"

The mum and dad, they looked like cartoon strip characters who continue to walk on the roof after it's finished, and realize too late that there is no roof under their feet.

Then the two stopped dancing and said, together,

"Sit down, please!"

The dad and mum obeyed. They were totally finished.

"Dad, this is my friend, P_4, and P_4, this is my dad."

"This is my mum, O_{10}, and mum, this is my friend, O_{10}."

Then they said to each other,

"Don't you think they look dumb?"

It took them a long, long time to look smart again, to figure out what had happened. Then they looked at each other, and smiled, unbelievingly, still remnants of dumbness sticking to their cheeks, corners of lips, and eyebrows.

P_4 and O_{10} were still enjoying their victory. O_{10} dropped her glasses, picked them up, and while helping her, the lighter fell out of P_4's pocket, but she didn't realize, ever.

❄

Symbrenthia Hypatia Chersonesia

He was positively wealthy, having inherited a large business from his father, who had died with mother in an air-crash; reasonable to look at, intelligent, twenty-eight, a loner with a slight, constant frown, an amateur etymologist and entomologist, and very very bored. His parents had died when he was sixteen; when he was eighteen, he could do whatever he wanted with the business, which he quickly sold at a twenty per cent loss, invested the money in a Swiss Bank deposit, and enrolled in the university, having decided two days after the air-crash, that he would never work or do anything else for money. He had decided that he would not make the mistakes that the first hacker, Hagbard Celine, had made. He would not go that way. He could've, and wanted to squander at least half the money—travel to places, take some friends along, go see the world, like the last tropical forests beside the Congo. But he had read about Hagbard Celine when he was thirteen, and decided that in spite of that swirling and throbbing intelligence (which had attracted him to Hagbard and Hagbard to the Illuminati stuff in the first place), Hagbard Celine had been stupid, typical of the 20th-century intelligent young men and women, who squandered money or life on inconsequential patterns of behaviour and meaning, or various forms of intoxication and loss of control. At thirteen, he already was a little more intelligent than Hagbard, and had actually planned out what he would do if his parents died suddenly. When they did, in fact, he was ready. He was in control.

He told the lawyers to appoint a good business manager in his father's place, preferably somebody who had just left Microsoft/Ford, or Nike, or Mitsubishi, or preferably, Sony; and if she failed to raise the profits in the first six months, to fire her, and find someone else. He made sure that in the two years that remained till he could control the business, get rid of the executors and trustees, the business would make more money, let alone stand still, or lose.

The moment he assumed control of the business, he sold it off, put some money in the Swiss Bank his father had used, and with the remaining he set up donations and trusts for hackers in jail (his lawyers would fight their cases at a discount of 1.34567%), painters with rheumatism or other diseases, and instituted a talent search contest for local musicians—preferring blues, because that's what he preferred. They all said, like father, like son. But they were not family, and did not know that it was actually his mother who had told him about death, explained everything that he then understood of human beings, and also was a secret financial wizard to his father.

He was in a StarryMouth bar with his current girlfriend, a raunchy girl always looking for fun and sex, when his phone rang, and he was told of what had happened. His girlfriend stayed with him for a day, crying at least twice as much as him, while he sorted out everything, but by midnight, she decided that he was way too cold for her, and never mind the money and the expensive fun. He was almost grateful. He had already had enough of raunchy sex in the oddest of settings, and locations, and positions. He almost preferred StarryMouth beer. The way there were sounds and harmless sparks in the mouth once you took a gulp was very enjoyable. It was like having the coolest of fireworks in the mouth. Naturally, all bars which served it had spotless mirrors. It was narcissism of a kind, he guessed. But he liked it. It was like the word "cynic" and he liked it. He liked to think of himself as a cynic, always mentally sneering at what other people enjoyed. He enjoyed sneering secretly in his mind. They all thought he was great fun, but that was because he was laughing at them, without letting them know.

There was almost nothing that could hold his mind for long. He had tried almost everything. But he found out soon that what he meant by everything was not much, and he set about systematically to educate himself. He enrolled himself in a university, of all places, and studied law. It was so easy that he abandoned his studies without getting a degree, then he studied painting for a while, for about six months, from the young woman who condescended to give him private tuition (she looked strange, and always seemed in pain, but she was a great painter—he had bought a painting of hers, of kids fighting with each other—without her knowledge—she had died about three and

half years later, of cancer) finally told him that he just did not have the control over muscle that was required for drawing even a sketch. He was, what, nineteen or over, then. Then he tried computation. But he was bad at it too, the man who wrote the PI told him that clearly. He broke open one of the deposits in the bank, and invested in the man's company. It had done well. He was richer for not being able to write programmes.

He was *twenty-three* when he discovered etymology, and entomology. Between these two dates, he confused the two, for both the disciplines treated their objects of study similarly: curious, beautiful, singular, and both the disciplines were celebratory. For three years he studied etymology from a linguistics professor at the university, who was impressed by the quickness with which he assimilated what was given to him, and entomology from another university professor, a very nice woman, who imparted the great amount of love that she had for the various insects that they studied together. He knew their food habits, their eco-bio-niches, he knew everything that there was to know. He donated money for research projects, and the university was then willing to overlook the fact that two of their professors were giving private tuitions. He had enough money. His software investment was doing very well.

Then he ventured out on his own, building a small lab on the edge of the City, working there with insects, studying principles of classification from Linnaeus down, the logic of these classification systems, and he started collecting ancient books—real ones, the ones that were printed on paper. Sometimes he paid hefty prices for these books, but always found them worth double the price. The smell of the book, the brittle feel of the paper, the beautiful typefaces, and above all, the language itself! He added a wing to his lab, put in temperature and humidity controls of industrial standards, and put all the ancient books there.

On the door leading to the left wing, where all the books waited for him, he put a sign, a large sign which said "Y", and on the right door, he put a sign which said, "NO". The rare visitor, usually some researcher or sometimes a professor, always asked, what does that mean? He was always surprised by that question—visitors were rare enough to allow him to forget that people ask such questions. He answered,

"These are the letters that are different in my two hobbies."

Usually, since very few people indeed had both these two interests, he had to explain further. People were strange. He was still not used to the ways of people. He explained,

"I have two hobbies, or passions, if you insist. Etymology, and Entomology. If you subtract the letters that are common to these words, you are left with y and no. Don't let the position of the letters on the right hand confuse you. It does not mean no, it merely means n and o. It could very well be o and n, but that's not the sequence in which they occur in the word itself, which I have preserved. I am a preserver, I hope you have realized that, if you are here to speak to me and discuss?"

But of course the visitor always had his or her interests and motives, and was not interested in what he was. They had whole careers dependent upon what they could get out of his lab or his collection. Poor things didn't have the money, and so were forced to be selfish. He on the other hand, having no need to earn money, did not need to have a career of any kind, and could follow his own desires in a way that nobody else could.

He was already getting a little tired of Indo-European languages, and was getting interested in earlier, Japhetic languages. He was thinking of going to the Basque areas and learning Basque. But more than the 20th century, it had become an area where there was constant fighting between the various groups that lived there, and the two nations of which the area was a part. He could not go there yet.

Without realizing, almost, but obviously out of choice, he became a loner. Over a period of months, he stopped taking the bus to the lab, and started walking there and back every day. It was enjoyable. It took an hour almost, and he used that hour to think about things. He didn't have to make unnecessary conversation with strangers. Sometimes he stopped and sat in a café, watching people, watching the waiters and waitresses, watching the coffee, smelling the grinding of the beans.

Quite often, returning in the evening, he sat in the cinema and watched horror movies, wondering why people needed to think of moths and beetles and cockroaches as horrific. He wondered what he

would do if he was confronted by a giant-sized cockroach, or some alien creature. He would know how to talk to it, he decided. He would stretch his arms, and with his fingertips touch the thick and large proboscis. They would connect. They might even hug each other, he thought. There would be no fear on either side.

In what he called the lab he did not keep any specimens. He did not like to kill the creatures. He photographed them, and put these pictures on the cyber counterpart of his lab. There were at least a hundred odd visitors there every three hours. There was a whole community of entomologists who used that space for discussion, sharing pictures, talking about rare finds. He monitored all that, and felt happy. The best, of course, were young children who flocked together and came in together into the space and took copies of pictures. One could almost feel them staring hard at the beautiful moths and butterflies and beetles. Sometimes they wrote, sometimes they called, and then he could see them, and share their excitement, explaining feeding ranges, metabolic rates, body-food ratios, flight patterns. It was wonderful to earn their respect through patient explanation.

He followed a strict pattern, almost like clockwork. He was in the lab by ten, having walked for an hour. He made some coffee for himself, chatted a little with his machine, or with the cyber-space maintenance woman, on the phone, and then started digging into cyberspace for tracking some rare species. He ate lunch in a nearby café, had some more coffee, dug some more. Then he walked back home around five, catching a show at six on the way if he felt like it.

Rarely did he feel the need to connect with anyone else. The cinema was the only place where he was amongst a crowd of people. He was very happy in the company of his pictures of insects. So many of them had died out, as a whole species. When a bird species died out, their specific lice also died out. The Passenger Pigeon Lice, for example, were thought to be extinct, then were found again, but now were again lost, this time lost forever. He was in touch with everybody who was working on identifying extinct species. They all met every week, shared notes, and quite often he hosted them in his cyberspace. He always told the children who visited about at least

three lost species, and instructed them on what help they could give in conservation.

It was when he felt particularly sad about the beautiful butterflies that were lost forever that he stopped at the cinema, and watched a movie. Screen Four was his favourite screen, there they screened mainly horror films. Some of them had SQ Sajnovics, and then he really enjoyed the film. He did not make any conversation, he did not laugh with the audience, or scream with the adolescents when she appeared on the screen. If anybody addressed him, he smiled and pretended to be deaf, or mute, or merely frowned. He generally disliked people, since he knew that they were going to be responsible for the loss of many other species before they themselves died out. He totally identified with the giant-sized insects which were killing human beings on the screen, tearing limbs apart, or devouring them in their incredible mandibles. They would have their revenge, he thought, and enjoyed the film. It was such a relief that SQS always knew how to deal with them. They never killed her or harmed her. She did not take a fire-spouting gun to them, neither ordered armoured vehicles. She always talked to them. Yes. She was good.

Sometimes, in the interval, he smoked a cigarette. He controlled his smoking systematically, he knew that the mentality he had might make him a chain-smoker, and though the cigarettes were much less harmful than earlier, they still could harm. So he stood in the smokers' corner, looking at people looking at him smoking, which had gone completely out of fashion by the time he had smoked his first. He smoked and went back into the hall to watch the rest, and the inevitable defeat of the creatures, while SQS flirted with the captain, or the general of the armed forces.

He stood there, smoking, when he heard a voice say,

"Excuse me, can you give me a cigarette please?"

He was startled. Nobody spoke to him usually. And certainly they didn't ask for a cigarette.

He looked up, to find an ingratiating smile on the man's face. He did not want to have a conversation, or even say anything, so he took his pack of cigarettes from his pocket, and pulled one cigarette out, and held it straight so the man could take it. Perhaps a smoker

who has given up, and is tempted, what with that scene in which the creature's proboscis had caressed SQS's thigh. He felt a sudden revulsion. He wanted the man to go away quickly. But he wasn't even taking the cigarette.

He looked up again at the man. The man was smiling, looking at him expectantly, as if he should be performing some trick. He did not know what was expected of him, and merely stared. Then the awful man said,

"Please put it in my mouth."

"Wha—"

The man kept smiling. A strange nausea came over him. Then he noticed that there was something wrong with the man. His shirtsleeves—he didn't have any shirtsleeves. He didn't have any *hands*. Just the shoulders, and from there down, nothing.

The man was still smiling, almost enjoying his embarrassment. He took the cigarette and put it in the man's mouth. Then quickly he lit it. The man thanked him and turned away. He was so overwhelmed, and disturbed that he could not really watch the rest of the movie. He kept thinking about what had happened, and what an incredible event it was, how singular. It was like discovering a new species.

After the movie, he trudged back, not really wanting to go home. He would keep thinking about the man. He needed to talk to someone. There was no one to talk to. The harsh realization that he was alone, with no one to call, or talk to, hurt him. He considered eating something in the café. But he still felt the remnants of that intense nausea he had felt shifting in his stomach. He decided he would get into a bar and have a drink.

He turned away from his steady route, and decided to go to the snazzy bar near the A Corner at Triangular Park, where he went once or twice in a month. But this time since he was going there from his lab, straight, he would have to take the small bridge meant for pedestrians to cross the river. Perhaps the river—yes, there would be water in the river. There would be a breeze. His step quickened at the thought. To calm himself, he began reciting the names of all the lost species of *lepidoptera*. Then he recited his "explanation for intelligent children." "Most *lepidoptera* smell with their *proboscis* (movies always get that wrong), taste things with their feet, and

they cannot hear, or make a sound. Their normal life cycle, depending on weather conditions and several other factors, is usually a few weeks long. In many species, you can see the colour of their wings just before they emerge out of the pupa case. After they emerge, they usually hang upside down for some time—they use gravity to get the fluids pumped into their drying wings."

"Butterflies belong to the Insects>*Lepidoptera* category. They are called that because they have scales on their wings, really tiny scales which are always arranged in very beautiful colours and patterns. As they age, they lose some scales. See that picture? Notice the right wing? A bit of the wing is missing there. They breathe through tiny parts on their thorax and abdomen, called spiracles. They eat through their *proboscis*. They lay their eggs very carefully, choosing a leaf because the moment the larva comes out of the egg, eating its way out of it, the larva must feed. Larvae must feed a lot, otherwise they die. They shed their skin a few times, and then spin a silk cocoon around themselves. This is the last stage of their development. When they come out of the cocoon, they will have transformed themselves into butterflies."

He was almost at the bridge. The first lamp on the bridge was flickering. It went out. Then it came on again. There didn't seem to be anybody on the bridge, for which he was grateful. He climbed up the few steps, and then he was on the bridge. There was a cool breeze, though the smell was not pleasant. He stopped feeling warm. He stood there, just after the steps, leaned on the railings, trying to look at the reflection of the City in the water. There wasn't much to see, but the breeze was nice. He felt better. The armless man had disturbed something deep inside him. Perhaps he should be studying human beings, he thought. Surely they also suffer. Perhaps some varieties of human beings are forever lost. Nobody had kept track. He only knew of the variety which was lost because of European imperialism, some small island on their trade route, had this variety of human beings who talked in whistles, then Europeans landed, and brought influenza with them, and eventually this cave-dwelling variety was lost.

Perhaps he should also make friends with people, he thought. It was alright now, but after a few years, when he got old, what would

he do? Really, he shouldn't be such a misanthrope. He should learn to mix with people. He remembered his adolescent days, when making friends and making love was so easy. Nowadays he hardly even looked at women. He should get to the bar, maybe, and start today itself. He stood there in his reverie for full twenty minutes.

A stronger gust brought him back to himself, and he sighed and started walking. He looked up to find there was someone walking towards him, from the other side of the bridge. A very young girl, maybe fourteen or fifteen at best, wearing a maroon striped and spotted blouse with a yellow jacket, and a dark brown purple skirt. As she passed a light he took a deep breath involuntarily. She was immensely and truly beautiful. She was feeling cold, though, she was hugging herself. But as she came closer, he was utterly dismayed, and something snapped inside him. It was not that she was hugging herself from the non-existent cold. It was that she didn't have arms. It was as if a calamity had struck. Twice! And consecutively. She was staring hard at him, at his mouth wide open from shock. She stared at him hard as she came closer. He turned a little aside, tried to compose his face into the urban blank innocuous expression. She had clearly seen his embarrassment. There was a faint smile beginning in the corners of her exquisite mouth. She stepped directly into his path and stood still. He bent his head once, as if to receive a blow. Then he looked up and found that she was grinning from ear to ear. He was totally confused. What did she want? Why was she grinning? Then something moved inside her jacket, and two hands emerged in front, like a flower opening. They opened further, her elbows flared the jacket open on both sides, and he could see the inner lining, blazing yellow, spotted and striped with maroon, the curve of her breasts as her hands lifted. She looked like a very beautiful butterfly opening its wings for the first time. It was only then that he heard her bright laughter, saw the glint of her teeth as she threw her head back and laughed and laughed.

He was beginning to grin stupidly, when she ducked past him, and was running away, still laughing. He yelled,

"Hey! Who *are* you?"

She stopped running, turned towards him, and waved her hands about as if casting a spell, and said,

"I am Fey, I am the Queen of the Fairies. I am going to change you!"

And then she cast her spell, and then she ran like hell.

He was alone again, but he was laughing.

With a spring in his step, he walked towards the bar. She was so beautiful. He was dazed by her beauty, her youth, her spell, her prank. God, he had actually tried to look sympathetic and sensitive. She was going to laugh at him forever. But he was going to do that too. He had been had in the most joyous manner.

He reached the bar, and sat down on the stool, and said to the bar-tender,

"Hi, how are you?"

The bar-tender said,

"Ah, it speaks. And it smiles too. Didn't know you could do that!"

"Can I have a Starry please? And a piece of paper and pencil?"

All the three items arrived together. He emptied half the glass, and opened his mouth, but did not look into the mirror. Instead, he took the paper and pencil, and began to draw a picture, folding it in the middle so that he could later trace a symmetrical pattern. When he was half done, the bar-tender came to refill his glass, and said,

"So what's that?"

"She is called *Symbrenthia Hypatia Chersonesia*"

"Sure. Does she speak English?"

"She's a very beautiful butterfly."

"What does she do?"

"Oh. She changes you. And she is truly beautiful."

"Really?" The bar-tender bent forward a little, as if to reach for a glass further away, and whispered in his ear,

"There is one very beautiful real woman staring hard at you. You want me to, like, send her a Starry from you?"

After a minute he turned, and saw this very mildly-dressed very good-looking woman.

He said to the bar-tender,

"Maybe next time. It's too early. I am just beginning to change."

Then under the picture, he wrote, in minuscule letters,

Life>
 Insects>
 Lepidoptera>
 Ditrysia>
 Papilionoidea>
 Nymphalidae>
 Nymphalinae>
 Symbrenthia>
 Hypatia>
Chersonesia
Common English name, The Intricate Jester
Such>
 A>
 Beautiful>
 Butterfly>
 Truly>
Beautiful

❅